Capturing Mood in Watercolor

Phil Austin

Capturing Mood in Watercolor

North Light Publishers

Published by North Light, an imprint of
Writer's Digest Books, 9933 Alliance Road,
Cincinnati, Ohio 45242

Manufactured in U.S.A.
First Printing 1984

Library of Congress Cataloging in Publication Data

Austin, Phil, 1910-
 Capturing mood in watercolor.
 Includes index.
 1. Watercolor painting—Technique. I. Title.
ND2420.A88 1984 751.42'2 84-6004
ISBN 0-89134-069-6

This book is gratefully dedicated to my teachers, including the first, my dad; to Eddie, who has been these many years a patient, loving and helpful artist's wife; to our children—my first students: Scot, Patricia, Joan, Jari, and Virginia; and to the many students who have followed, from whom I have learned much.

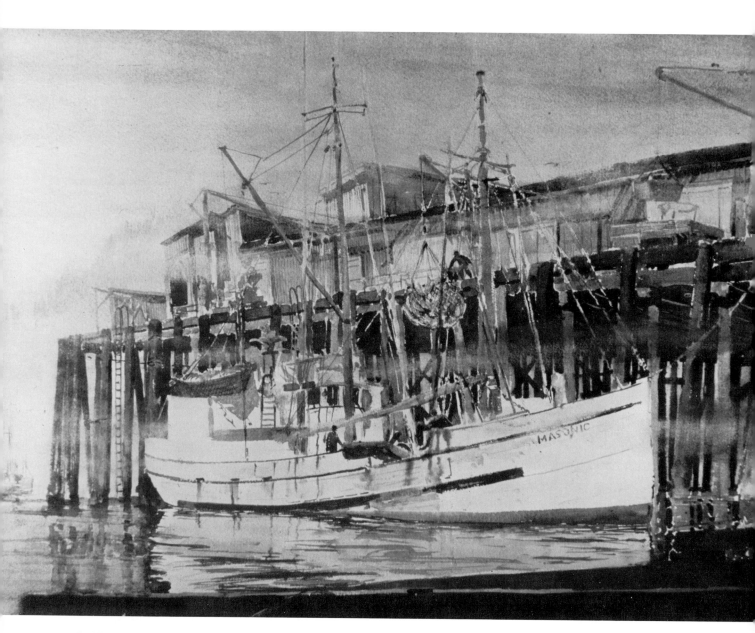

Halibut Boat, Petersburg, Alaska
Watercolor, 21x29 inches
Collection of Mr. and Mrs. Leon Zygmun

*Petersburg is a lovely, clean little canning
town on an island at the end of the Wrangell
Narrows. There are many fishing boats in
the harbor and one was in the process of un-
loading a catch of halibut. There was a rath-
er heavy fog that day and when the painting
was finished I misted it with a spray bottle
and dragged a brush across the surface in
several places to increase the feeling of rib-
bons of fog.*

Contents

Contents

9

Foreword

In today's world there is a strong inclination to remain in our own small niche, the idea being that if we become "involved," we make ourselves vulnerable. We live in an apartment building or on a quiet street and fail to get acquainted with our neighbors. If we make acquaintances, we never get involved in personal conversation. We don't express our opinions lest someone disagree with us. We don't voice our deepest feelings for fear we may be ridiculed.

In spite of living in this kind of restrictive climate, many individuals still feel compelled to express themselves. Some write letters to the editor; others champion a cause; some write articles, books, or poetry; others act or compose music. And some create objects of art.

Having done a large number of watercolor workshops, I have found that people paint for numerous and varied reasons. Some are seeking relaxation—complete absorption in a field widely separated from their daily occupation. Others have found that painting increases their awareness of the world around them. What a pleasure it is for me to travel with a group and after a week of painting note their greater appreciation of the landscape on the trip back home than they showed on the outbound trip. Still others are looking for a means of expressing their interpretation of what they see about them. Many are seeking personal satisfaction through a sense of accomplishment by developing an individual skill.

Many of the ideas set forth in this book are not new or original with me, but time has shown they offer the serious student a better use of watercolor as a painting medium. Many of the procedures will apply equally well to any means of picture making, although they have been set down with watercolor painting in mind.

I have tried to set forth in simple terms and demonstrations the way I think and work. Whether you are already an accomplished painter, an advanced amateur, or even a hopeful beginner, watercolor is an "open end" medium. There exists no level of accomplishment beyond which the painter cannot go.

This book has been written with the hope that it will aid all who seek help. If it shares with you my enthusiasm for watercolor painting, the joy of spontaneous creation that comes with watercolor, and the emotional release of telling the story of the beautiful world we have about us, then my purpose has been accomplished.

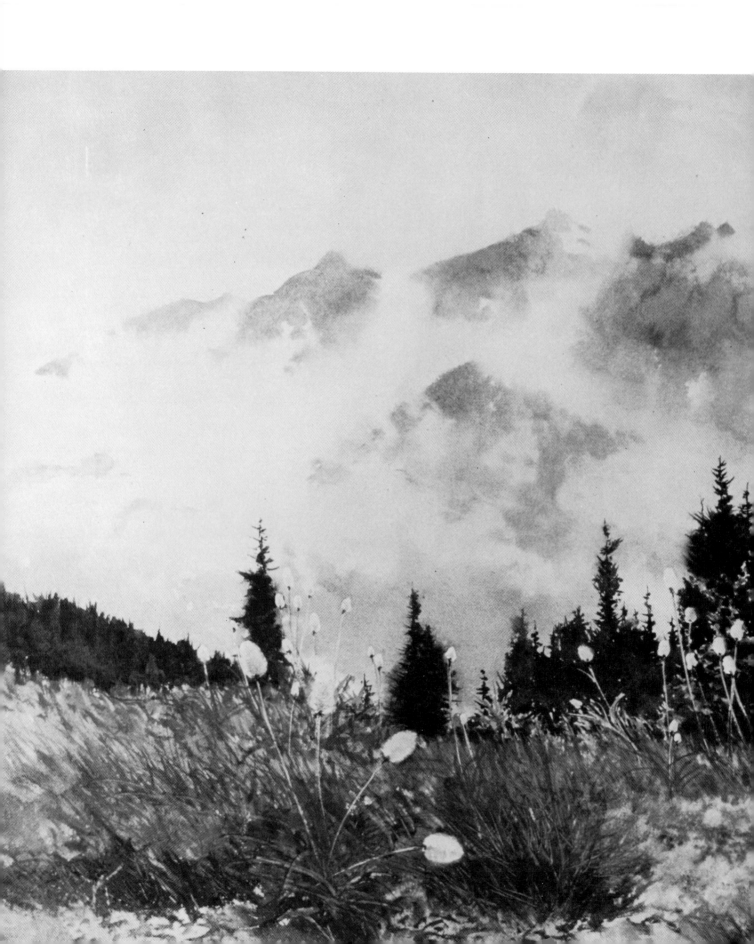

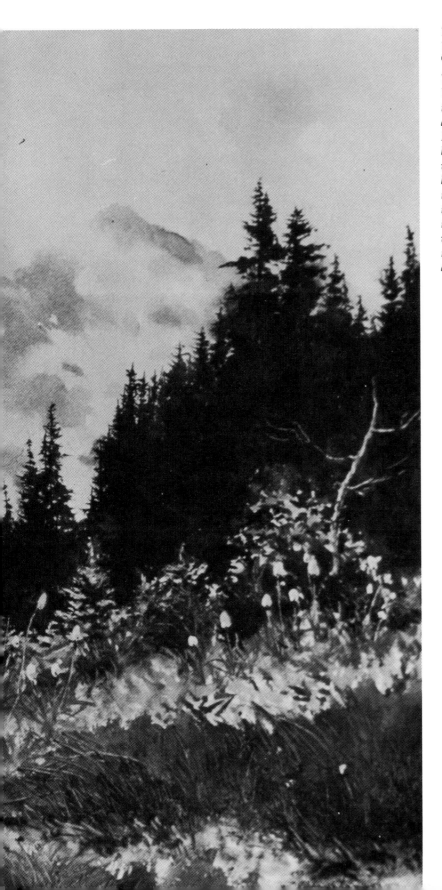

Beauty at Hurricane Ridge

Watercolor, 21x29 inches
Collection of Mr. and Mrs. Leon Zygmun

This mile-high spot in the Olympic Range in Washington state is a favorite of mine. On this day, there were scraps of cloud above and below and it seemed like another world. I used liquid masking for the bear grass blooms, painted the shrouded range wet-on-wet, the foreground with dry brush, and did brush-handle detail in the damp wash. Additional spatters of color gave a gravelled look to the foreground soil. The cedars were misted in a few places with the spray bottle while damp, to soften edges. Finally, the mask was removed, and the blooms received a slight warm wash to mold them.

Life and the World of Watercolor

Is talent an innate ability or a genuine love for a particular pursuit? At least one of the chief ingredients of talent is surely the love that puts a certain endeavor in the forefront of one's activities.

A natural ease for drawing or painting without love for it accomplishes little. An acquaintance once said to me, "I really enjoy doing watercolors. If I had the time I'm sure I could do some really good ones." When asked what kept him from taking the time needed, he replied that his sailboat required a lot of work every spring and that, of course, in the summer he liked to spend most of his spare time on the water. His talent was water, not watercolor.

Painting, like any other skill, makes real demands on our time if we are serious about it.

When I was very young we lived on a small farm at the fringe of a Lake Michigan harbor town. The deep-throated call of the lake freighters nosing into the harbor brought a desire to interpret that excitement in a painting. One night when we visited the slip where a freighter was moored to unload coal, lights blinked everywhere, conveyors clattered, the deck lights seemed as high as the sky and

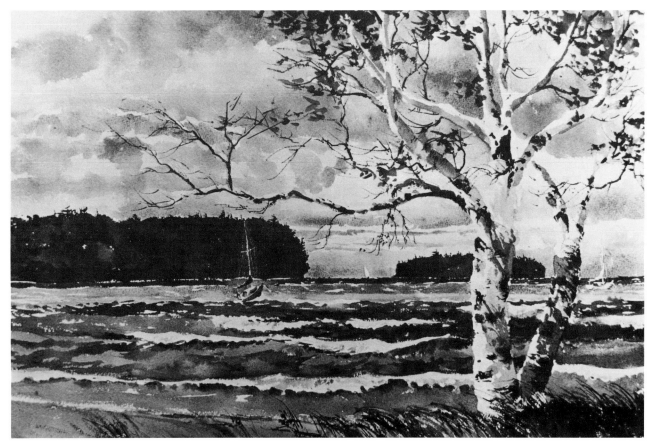

Wind at Ephraim
Watercolor, 14x21 inches

The wind fairly rocked the car as I painted this subject. Lots of white paper was left for curling spray, light on the birch, and passages of clouds. The distant sailor, the bro- *ken sky, and the anchored sailboat in the middle distance rearing at its mooring suggested wind. I used the turmoil of the strokes to suggest sound as well.*

glimmered into the darkness for a mile! My enchantment was complete and my interest in working boats was born. Life was nudging me to paint.

There are many ways of storytelling. Some do it with a marvelous command of words. Some choose music, while others paint. Regardless of the medium, all are ways of manifesting emotional expression.

I constantly drew pictures, as children do, and the gift of a small box of brushes and paints ushered me into the joyous world of painting. Things that interested me and stirred my emotions prompted the desire to express them in paintings. The far-off whistle of a night freight carried on the wind, or the sight of wooded hills and rolling fields drifting in the blue haze of autumn brought wanderlust, yet demanded more than just exploring the beyond.

Figure 4

These three sketches indicate the process of analyzing a subject for areas and shapes of value. Triangles, rectangles, and circles are

a simple way of indicating objects of varying value. Once the composition is established, the drawing is easily completed, and ready

to be developed into the painting on the right.

With a dad who was sensitive to my moods and interests, I sketched the river bank: bushes, boulders, deep pools and eddies. I scanned the countryside from the hilltops, and studied shadows on country roads. All became entangled with my dreams and desires. So began the training of a storyteller.

I attended the University of Michigan because excellent art classes were available in the architectural school. My excitement about the courses and love of the atmosphere of the art school gave me thorough enjoyment and exposure to the art world. At that time watercolor painting was introduced to me. The ease with which some of the students flowed their colors and achieved satisfying results made me envious and frustrated, but my early discouragement was offset by a rapidly growing love for the medium and a determination to master it.

Frequent visits to the excellent school art library brought me an awareness of many great painters, including Constable, Inness, Turner, the French Impressionists, the American painters—Homer, Burchfield, Hopper, Marin—and the current watercolorists Whorf and Heitland. One book which I constantly returned to was a fine volume with many superb plates of the works of the British painter, Russell Flint. His mastery of beautiful washes still amazes

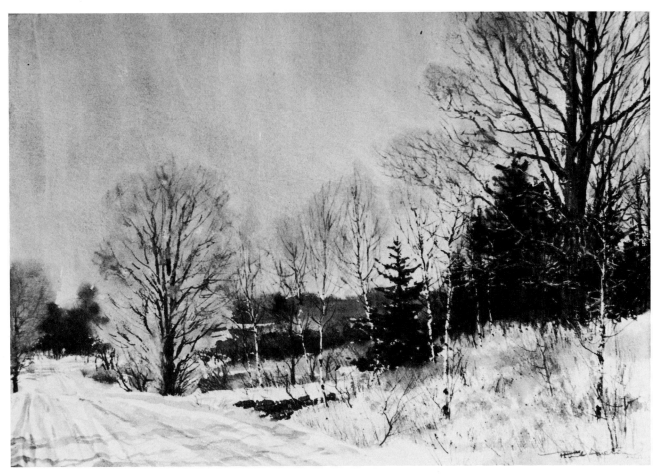

Afternoon Shadows, Timberline Road
Watercolor, 21x29 inches

This little ridge on the road near home never fails to intrigue me. On this day the sun made warm smoke of the myriad twigs on the maples, a distant cherry orchard had a deep red-purple color, and the evergreens were rich and dark. Shadows gave contour to the snowy ruts. Exposed dry grass gave color to snow areas. Soft wash on the wet sky was used to shape tree tops. The distance was also laid in wet to give softness.

me. A few years later it was possible to study some of the work of many of these artists firsthand in Chicago galleries and at the Annual International Watercolor Exhibition, held at the Chicago Art Institute. About this time I also began to see and admire the work of Andrew Wyeth.

At the university our painting classes followed the pattern (much disliked by many students today) of working from a carefully planned still life. There was much validity in this method of learning. The objects that emerged from the property cabinets were endless—simple sculpture, beautiful plates, bowls and vases, background drapes, bottles in all shapes, sizes, and colors. Plants, fresh fruits, and flowers were often added. Thus we were introduced to the challenge of capturing textures, form, colors, light, and shadow—compositions under a constant light source—and were not confused by changing conditions, which could have easily happened since we were beginners.

Two of these early still lifes remain in my mind for specific reasons. One contained a clay pot of "hen and chicken" cactus. Its complexity taught me to work wet and strive for an interpretation rather than a painstaking rendering. The other subject was an Indian pottery with a brilliantly colored serape. I became aware of the simplicity of the rich, earth-colored pottery against the play of bright color and painted with new purpose. I learned that it was better to express feelings about a subject than to play the part of a camera.

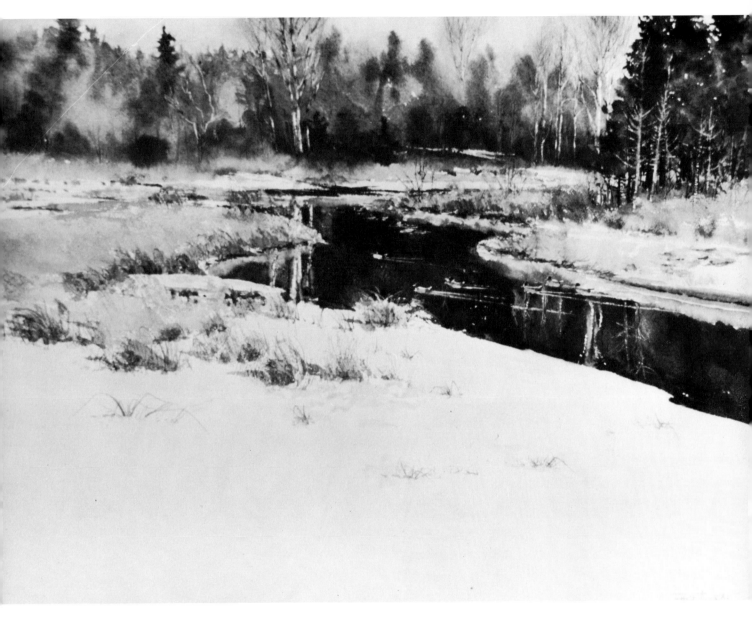

Open Winter
Watercolor, 28x36 inches

Going Out to Paint or Bringing the Out-of-Doors to the Studio

Painting on location can be a rewarding experience. It sharpens observation and teaches selectivity, and it can result in a mental bank of useful information and detail. Working on location will make you a part of what is going on so that you will paint with more understanding.

For many years I painted entirely out-of-doors. Eventually, by taking photo slides of my painting subjects, I was able to increase my source material, which resulted in more creativity back in the home studio. Studio painting then became a great experience with more opportunity for study and experiment, based on what was learned on location.

Many things often interfere with painting out-of-doors. Time may be limited, at times even a place to sit and work is virtually impossible to find, or the weather may be prohibitory. However, trying to paint from slides or photos without enough prior painting on location to get the "feel" of the area, the color, and the activity taking place is futile. Try to imagine doing a portrait of a person from random snapshots which capture a passing mood entirely unlike the person, and you'll know what I mean. Photos are valuable as reference material and should be treated as such, not as a picture to be copied.

A Painting Career

Further study in night classes at the American Academy of Art in Chicago followed. I worked for several years in a large commercial art studio in the city and even though I enjoyed the work, I yearned for a painting career. Freelancing followed, and I was allowed more time for painting. Those years were valuable, a good discipline, and gradually brought me to the point of "taking the plunge" into full-time painting.

I have devoted my entire energy to painting for some twenty years now. It has been a most satisfying life. Being a workshop instructor in recent years has taught me a great deal, while I have sought to help others. In the pages that follow, I'd like to share my enthusiasm for the joy of expression in watercolor and the methods effective in achieving these goals.

Searching with Watercolor

Emotional Response

The wonder of life is the immeasurable beauty in the small area of the universe with which we are acquainted. Even more amazing is the fact that our Creator has made each of us capable of experiencing an individual emotional response to what goes on about us. I believe that the nebulous gift called "talent" is the degree of our emotional response. The stronger that response, the more likely we are to create something tangible, be it prose, poetry, music, sculpture, or paintings.

It may never be our privilege to personally realize the impact of that revelation on others. But by whatever means, our expression must be completely honest. It will be an exposure of our innermost selves. Our work will be *us*.

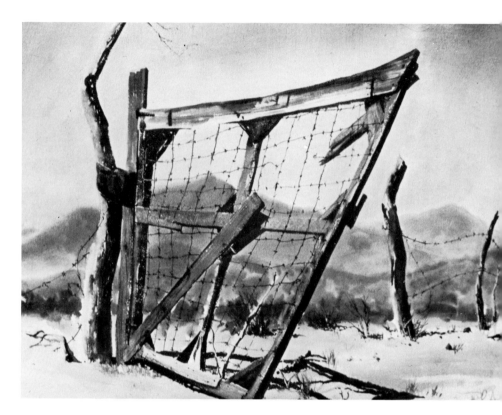

Figure 6

As artists, we have a responsibility to create awareness in others. It takes a great deal of searching and practice to translate emotions into visual images. How shall we reveal the incredible beauty of nature in its uncountable aspects? Or how will we show the beauty man has incorporated into the objects he has created for daily use? Sometimes remnants of the past stir more emotion than the substance of our present lives. These challenges make watercolor an exciting search.

Watercolor may become your overwhelming choice, as with me. I think it is the most exciting, the most versatile, the most expressive, and perhaps the most baffling medium of all.

Gate to the Sierras
Watercolor, 21x29 inches
Courtesy Sierra Associates

This painting near the bottom of the Baja Peninsula was painted wet-on-wet, with the fence and gate detail added when dry. It was intended to suggest that man's efforts are temporary, but mountains are forever. Absence of people or animals suggests the lonesomeness of the area, which is characteristic of the Baja.

Living in the country the majority of my formative years, I developed a genuine love for the out-of-doors, and turned naturally to painting landscape. Awareness of so much beauty prompted a desire to capture on paper those qualities that are so often momentary.

Watercolor is ideally suited to expressing the emotions and moods nature inspires. It is flexible, fluid, and subtle. It invites spontaneity. And because its results are often unpredictable it can be full of surprises. You may complete a painting and find effects you did not consciously strive for. I believe that God helps us to exceed our humble ability, whatever we are doing. This is especially true in painting with watercolor, and it adds joy to the experience.

Versatility of Watercolor

Because watercolor is such a versatile medium it can become, more than any other medium, an incentive to have fun when you paint. It will lend itself readily to a vast variety of subject material. With practice and an increasing ability to handle watercolor comes the urge to tackle more and more diverse subject material. You may be challenged by the seacoast, as well as rapids and waterfalls. You may find it fun to incorporate deer, foxes, horses, and cows into your works and then enjoy going to sketch class to paint figures, and even portraits in watercolor.

The discipline of using watercolor simply sharpens one's observation, and forces direct work. Practice in a sketch class makes it much easier and more fun to add figures when needed in a painting. Simple quick sketches will help you master painting water, trees, or skies.

If you lean toward being a documentary painter, you will have fun doing such subjects as the old rusty lantern shown in Figure 7, a rock outcrop, the end of a stone wall draped with snow, or a section of an old building.

As a watercolor enthusiast, you will eagerly search to find the best way to tell the softness of tawny meadow grass blowing in the wind, the fresh, pale beauty of the yellow-green smoke of spring willows against the darker backdrop of woods, the rugged individuality of old gnarled and twisted trees, the silver of water shimmering in the morning light, the sparkle of a brook picking its way over rocks and stones between dark banks of earth and the vast changing mass of clouds creating an endless landscape in the sky. For all of this, watercolor has much to offer.

The more your initial washes imply by directness and simplicity—by direction of stroke, texture, change of value, choice of color, looseness of application, emotional expression and elimination of unnecessary detail—the better your painting will become.

Emma's Lantern
Watercolor, 15⅝x11¾ inches

This rusty old lantern was painted with a charged wash of ultramarine and vermilion. Table salt was then dropped into the wash to create the effect of rust as the values were molded. A little cerulean added here and there gave a hint of the color when new. Old weathered boards further suggest age.

Figure 7

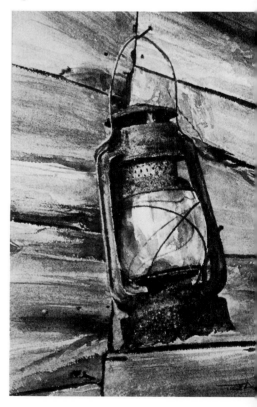

Painting on Location

If you plan to go very far on foot to reach a painting location you will soon learn to scale down the amount of gear you choose to carry. A couple of bad falls while overloaded without a free hand to catch myself discouraged me from carrying more than the absolute essentials. I now carry a fairly lightweight plywood board with my paper taped to it, a simple collapsible stool, a plastic water bucket large enough to hold a gallon jug of water, and a simple shoulder strap case for paints, brushes, paint rag, pencils, erasers, a spray bottle, sketch book, my camera and some *insect spray*. This last item is often a necessity!

24

Figure 8

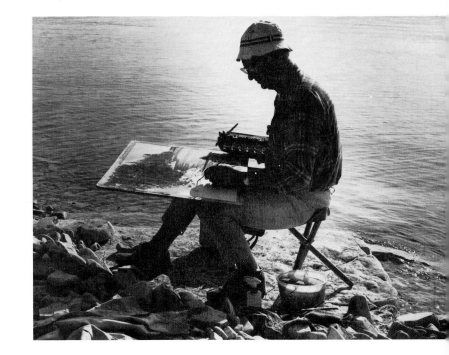

Painting on location
Sitting on a comfortable stool, water bucket nearby, paper on a board across the knees, paint box securely in hand, makes it easy to work on location. The board can be tilted in any direction to control the wash. Being near the ground makes other tools easily accessible.

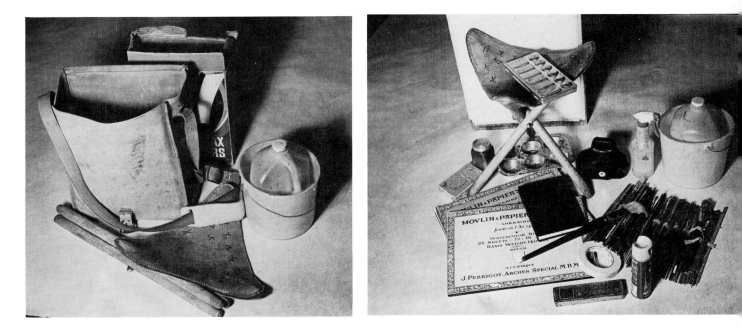

Figures 9 and 10

Shown is the handy leather carrying case, together with the cardboard liner, a comfortable collapsible stool and an adequate water supply. In Figure 10 are the items which will fit easily in the case. (With the exception of the stool and water.)

Since an easel is a bulky extra, the habit of sitting on a stool with your board across your knees may prove helpful. Never gamble on finding water when you are taking a long hike to paint! I hiked through the woods and brush out to the coast in Washington state once, only to end up with a fantastic beach subject two hundred feet below and no access to water!

The case shown is a simple leather one which can be made by a local leather craftsman. It is 7x13 inches by 16 inches deep, and accommodates a large discarded cardboard soap box which fits perfectly and stiffens the case. There is extra space around the side for

25

two 12x16-inch watercolor blocks. (I carry a cold press and a rough block with me for additional painting or sketching.) There is also room for a 6x8½-inch sketch book, an extra large wash brush or two, and a roll of tape.

You may find it valuable on extra bright days to take along a light nylon beach umbrella with a sectional aluminum spiked shaft to shade your painting surface.

Painting in the studio.

If you plan to paint regularly at home you will want to arrange some permanent work space so that everything doesn't have to be dragged out and put away every time you wish to paint. If you are fortunate enough to have a spare room with north light it should make an ideal painting space. You will also need suitable work space for matting and framing, and storage space for mat boards, watercolor paper, reference material and books, as well as a place to keep all gear for outdoor sketching and painting. Go to a good art supply store and discuss the type of artificial light best for painting. Either the proper balance of fluorescent bulbs or a combination of fluorescent and incandescent lighting should be considered.

Figure 11

My well-lighted, pleasant painting area. The silk-screened drapery material with a colorful pattern of brush strokes was a real "find."

Figure 12

Study area flanked at one end by shelf of books, at the other by a matt board storage area.

Figure 13

Alcove work area off the corner of the studio, providing the space needed for matting and framing. A number of convenient storage shelves are provided below this working table.

Materials—Pigment

Materials are very much a matter of individual preference. However there are some basic rules to follow in choosing them. Whatever your way of working, except for purely practice sketches, it is wise to use good materials. A little care in selecting pigments, for example, will insure using non-fugitive colors—a must if you plan to sell your work. Look on the color chart of whatever brand you choose and check the permanency rating given each color. It is a great disappointment to have created an exciting watercolor, only to discover later on that one or more of the colors are beginning to fade in the light. Brands may vary somewhat in the characteristics of particular colors. It is wise to settle on a brand you like and then always use the same pigments. The consistency will help your painting. Having begun with Winsor & Newton's, after a little experimenting with other brands, I have continued with them through the years, now using their "selected list" pigments in the large tubes.

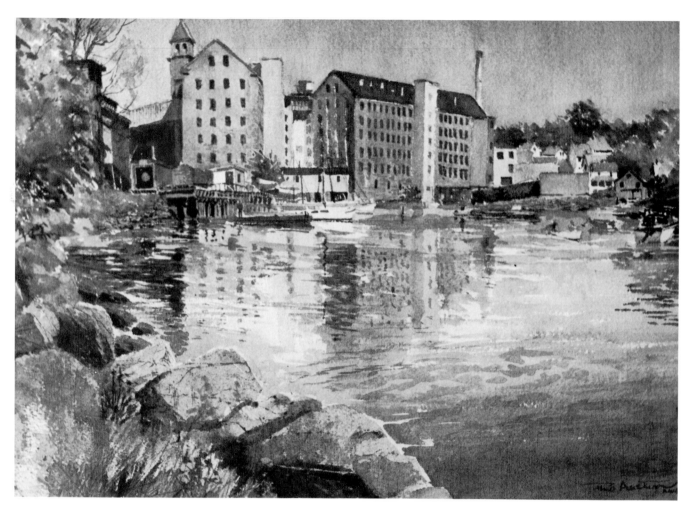

Figure 14

Old Stone Mills, New Market
Watercolor, 13½ x 21½ inches

Paper

As to papers, the important thing is to use 100 percent rag paper for your serious work so that your paper, like your color, will be permanent. One-hundred-forty-pound is a good weight to use, but it should be stretched to make it flat. If you go to 300-pound stock you will only need to make stretches for the wettest paintings. The heavier paper is much more apt to lie flat under the matt when framed. Handmade papers give a wonderful quality to a painting. Some are hard to find. There are, however, a number of good papers available. I like D'Arches. For smaller paintings their 12x16-inch blocks in cold press and rough are good. For half sheets and larger you will want to stretch 140-pound paper or use 300-pound.

This painting was done in New Hampshire at the height of fall color, so that warm color in the foliage contrasts with the cool gray of stone. Note the buildup of value at buildings' edges, use of shadow from buildings toward the left to create a dark-light axis in the river reflections. The lower right area of the water is deepened to fill the corner of the composition. The changing angles of reflections in this area change the flow of the river as well as strengthen composition.

Stretching Procedure

A good stretching procedure: Soak the paper briefly in the tub or shower and spread it on a piece of ³/₈-inch plywood and tape it down securely with 1 or 1¹/₂-inch paper packaging tape. To avoid trouble with this tape coming loose, remove moisture ¹/₂ to ³/₄ of an inch from the edge of the paper with facial tissue or a paper towel so that the glue on the tape remains full strength. Moistening the tape by drawing it across a wet sponge will also avoid washing glue off the tape and will help insure a good stretch. As a further precaution, use a flat object and squeegee the tape tightly to the paper as it is applied. Most stretches break loose because glue has been washed off the tape or because the tape has not been pressed tightly enough to remove excess air—particularly with rougher papers. Once your stretch is made, allow it to dry in a flat position, not standing on edge, as this allows water to accumulate at one side of the sheet, again loosening the stretch.

Working methods, and sometimes the subjects themselves, will determine whether you wish to use a rough, cold press or hot press paper. I generally prefer rough or occasionally cold press for most of my work. If you plan to use lift-off methods to remove limited color, you may prefer smoother papers. The important thing is always to use good rag papers for anything but practice work. Cheaper papers tend to discolor in time.

Brushes

Brushes also are a matter of personal preference. I like sables and use a number of flats from ¹/₈ to ³/₄ inch wide—plus some #2 and #4 round sables. Occasionally a #14 round is helpful. Two or three large wash brushes, a 1¹/₄, 1¹/₂ and 2 inch, plus a #3 and a #6 rigger for doing branches, ship's lines and such, and a ³/₄inch aquarelle for texture and "brush handle" work will prove valuable. Some of the new white sable flats are also good to have. (You perhaps will want a slender painting knife for some scraping out.)

Palettes

There are a number of good palettes available. I prefer a lightweight aluminum box palette, made by Winsor & Newton, which has a white interior with small wells for color, larger mixing areas, and a thumb ring on the bottom, making it easy to hold when painting on location. (Especially helpful if there is much wind!) For a limited palette of seven colors, this works well and can be supplemented with an ordinary muffin tin, which has larger cups in which to mix color for extensive areas of wash. In the studio it is also helpful to use a plastic palette with large mixing areas.

Sketch Book

A bound sketch book of smooth paper (either 8½x11 inches or smaller) is a necessity, together with a supply of soft pencils, such as #2 office pencils or "B" or "2B" drawing pencils, and kneaded erasers. These allow for recording details on location and working out composition by experimenting with thumbnail sketches.

Miscellaneous

A liquid mask is good for occasional use. Choose one of the thin varieties, which handle much like watercolor.

A painting apron is helpful if you are inclined to slop color around freely. A towel across your knees will help for occasional wiping of the brush or for drying it slightly, since the use of a towel rather than frequent washing or flipping of the brush will avoid an unconscious waste of a lot of valuable pigment.

Two other items are a spray bottle with an adjustable nozzle, and a high speed electric dryer for studio use. The dryer will allow you to dry areas either to arrest action of the color at a desired point or to speed up your painting procedure.

Figure 15
A characteristic assortment of the brushes I use.

Planning Good Watercolors

The Limited Palette

To simplify procedure and get direct results I recommend limiting the number of colors on your palette. They should be colors that mix equally well with others in either direction of the spectrum without turning muddy, that produce rich darks without the use of black, and that are nonstaining and permanent. The following seven colors comprise a palette that meets these requirements. With practice and experience you may want to make substitutions or additions, but be sure your choices meet with the criteria just mentioned.

Alizarin Crimson
Vermilion
Cadmium Orange
Cadmium Yellow Pale (or tint)
Viridian
Ultramarine (or French Ultramarine)
Cerulean Blue

Learning to use seven or eight colors is much easier than learning to use twenty-five or thirty. Knowing the properties and characteristics of individual colors has a lot to do with how well you can use them. Some will float, others will mix readily, others will create a grainy wash—all characteristics that you can utilize to good advantage in creating various textures and visual effects.

Using a limited palette means constant mixing of color, which will teach color appreciation and sensitivity to subtle changes in color and value, thus sharpening our appreciation of what we see. The limited palette I prescribe is actually composed of the primaries—red, yellow, and blue—plus the secondaries—orange, green, and in place of purple alizarin crimson, a more versatile substitute for purple. It includes a second blue—cerulean—which greatly expands the range of blues. By the choice of hue of each color and by working transparently on white paper, the watercolor painter comes close to demonstrating the way colors behave when separated out of light by a prism.

The more rapidly you can assess color and create it on your palette, the more rapidly you can paint—a real asset in watercolor.

Recognizing what makes up a color makes mixing easier. It is possible to apply a value wash to your painting and, on the paper, do subtle color changes in that wash, making the painting more fluid, exciting, spontaneous and with more continuity—all qualities of a good watercolor.

A simple demonstration of this is found in Figure 16, where the top band illustrates the clear mix of each of the seven colors into the next. Since the cadmium yellow pale has no red in it, it mixes readily with either green or orange and remains fresh in appearance. Similarly, the green has no trace of red, so it mixes readily with yellow or blue, without losing brilliance. The ultramarine is a strong blue. It contains some red, which is useful, but for this reason, cerulean is also included in the palette since it has more of the character of sky and water, allowing lighter blues with no trace of red in them.

The second band demonstrates the use of vermilion and ultramarine to create a wash of gray, beginning just below white and graduating all the way in value to an approximation of black. The darks thus created have much more "life" than similar values created with black pigment. (Note: If you are having trouble with these values looking slightly purple, add a minute amount of orange.)

This method of obtaining the scale from light to dark permits the adding of color at any point, while moist, to change the hue without changing the value.

Figure 16

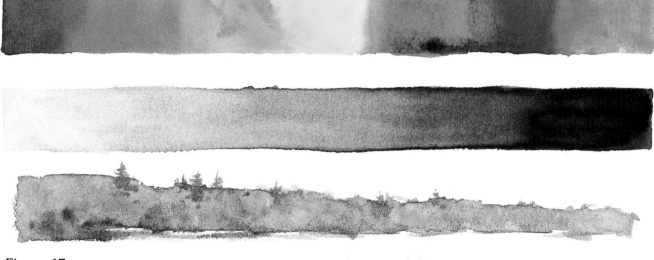

Figure 17

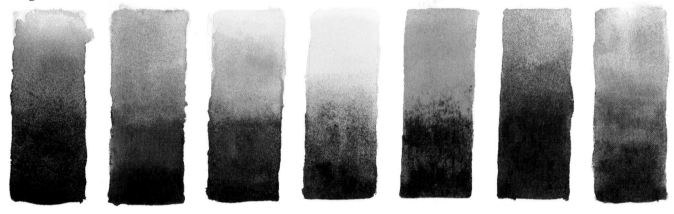

This is demonstrated in the third band which began as a middle value of neutral gray wash. A little cadmium orange added at the left end warms up the gray, while some cerulean added at the right end creates a cool gray. Then bits of cadmium yellow and orange, vermilion, alizarin, and viridian dropped into this wet wash give a hint of fall colors on a distant ridge. A few silhouettes of pines complete the illusion. The warmer gray and brighter colors on the left bring it visually closer, while the cool color on the right gives it distance. This has been achieved while keeping the value almost constant.

In the series of seven panels in Figure 17, each color in the limited palette was started with pure color, allowing it to blend into a guaranteed value of vermilion and ultramarine to create darker value. Note that each dark has become dominated by the particular color of each panel, not just a uniform dark. Practice with this way

of mixing will allow you to paint with color while putting the emphasis on value.

In Figure 18 a few examples of mixing greens are shown. In no case is viridian used as a pure color, only as an additive. Any variation can be achieved by changing the amount of each pigment used. The final two spots, lower right, were achieved by establish-

Figure 18

Viridian-cadmium yellow	*Cerulean-cadmium yellow*	*Cadmium yellow-ultramarine*	*Viridian-cadmium orange*	*Ultramarine-cadmium orange*

Cerulean-viridian	*Viridian-ultramarine*	*Cerulean-cadmium orange*	*Cadmium yellow-vermilion-ultramarine*	*Cadmium orange-vermilion-ultramarine*

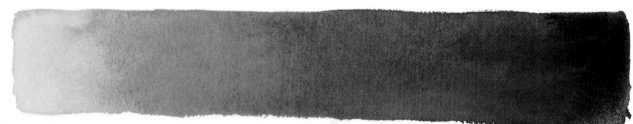

Figure 19 *Varying mix—cadmium orange, ultramarine, vermilion*

ing a value by mixing vermilion and ultramarine before viridian was added. In this manner, any kind of green, warm (orange added) or cool, can be created in as deep a value as desired.

The comment always arises, "But you have no earth colors in your palette." Figure 19 demonstrates why they are not needed. Beginning with pure orange at the left, the varying wash is controlled by the addition of vermilion and ultramarine to create the whole gamut of earth colors, down to the darkest value.

Two reds are needed because alizarin contains blue and vermilion contains yellow. Alizarin is particularly useful for mixing with blue for colors which tend toward violet, yet it is clear enough to mix with vermilion to create rich deep reds—such as the fall colors of maples and oaks. As for vermilion, it serves for mixing all the warm red and orange colors toward the yellow area of the spectrum. Vermilion also has another primary reason for being in the palette: it is an agent to create values.

Figure 20

Watercolor, 12½ x 29 inches
October in Ole's Woods *shows the use of alizarin, vermilion, cadmium orange, and a bit of ultramarine added here and there to deepen the value. Contrast of colors adds brilliance, as well as the scattered dark trunks, white birches, and the dark distant hills which cause the color to stand out.*

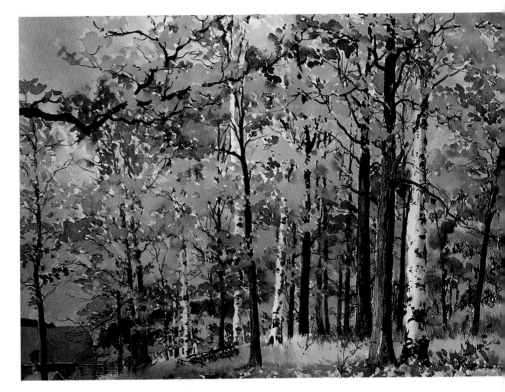

Figure 21
October on Collier's Ridge
Watercolor, 21x29 inches

Here the alizarin gives a cooler look to shadow areas of foliage, while cadmium orange gives warmth to the light side of the trees. Again, dark trunks and limbs provide contrast.

Cadmium yellow pale is a clear, pure yellow which can be mixed readily with the oranges and the reds, yet can also be combined with the greens and blues.

Viridian is an intense green, again so pure that it can be mixed readily with yellow or blue. There are few occasions when this color will be used by itself, one such exception being to represent sea water with the light coming through it in a curling wave. Generally viridian is used as a ''spice'' to liven up a mixed green.

Ultramarine is an extremely useful blue, basic to both water and sky colors. Ocean greens are achieved with a mixture of ultramarine and viridian. Excellent blue skies can be painted with ultramarine and cerulean, beginning with a very small amount of cadmium yellow pale added to the cerulean at the horizon, then pass-

ing through cerulean into ultramarine, then adding a small amount of vermilion to the ultramarine at the zenith. This sequence generates the feeling of the great vault of the sky. In addition ultramarine serves a second major purpose in this palette, that

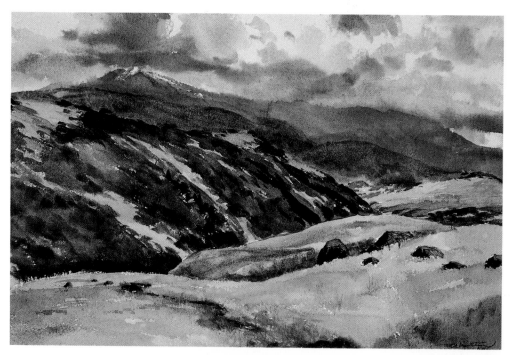

Figure 22

High Meadows Above Ashland
Watercolor, 13³/4 x 21¹/2

This Oregon painting makes use of a variety of greens to portray grass, some in shadow, scrub oaks on more distant hills, and shows blending of greens into the blue of distant mountains.

Figure 23

Putting Away the Straw
Watercolor, 13³/4x21¹/2 inches
Collection of Mr. and Mrs. R. Koepke, Jr.

Here a variety of greens have been mixed. A shadow falls across a green area and a much darker green was created, as described, by mixing ultramarine and vermilion to the proper value and adding viridian until it becomes a dark green. The distance is a gray with a little viridian added.

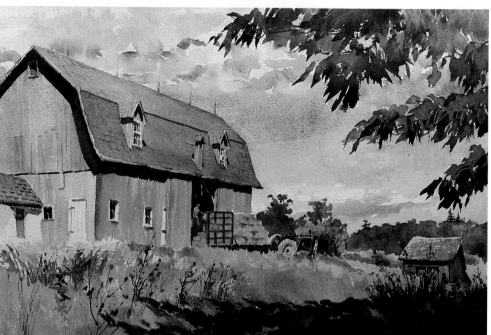

Figure 24

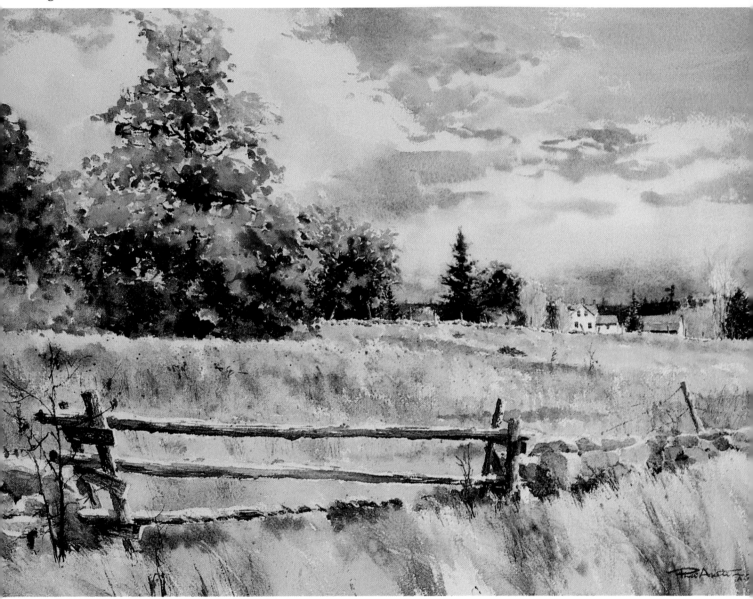

Octoberland
Watercolor, 21½ x 29 inches

This painting demonstrates the use of ultramarine at the top, cerulean lower in the sky, grays for cloud shadow, al-izarin, vermilion, and cadmium orange for foliage with ultramarine added to them for deeper value. The foreground is a very thin wash of cad-mium orange with a little ultramarine added.

of being the second agent to create value.

Cerulean, the final color, is needed for blues which have no red in them. Also, since it has a slightly opaque quality, it serves to modify other mixtures and is a big help in making neutral and cool blue grays. I'll mention this use of cerulean from time to time for specific purposes.

You will find that a great variety of greens can be mixed with this palette. Cadmium orange and ultramarine produce olive green. Cadmium yellow pale and ultramarine make clear greens. Cad-

mium yellow pale mixed with viridian or cerulean produces spring greens. Thus by using two or more of these last five colors in the limited palette an uncounted number of greens can be created, allowing for a subtle flow of change.

At the top of this palette the variety you can achieve—by mixing yellow and orange, orange and vermilion, yellow and vermilion, or yellow and alizarin—is endless. If you add a little ultramarine experimentally to these mixtures, you will discover that you can mix all kinds of browns, e.g., earth colors as demonstrated in Figure 19. In addition you can achieve extremely dark values which will still be color, a very important ingredient as you will see when we discuss the use of value.

Undoubtedly, the most important elements in this limited palette are the vermilion and ultramarine, since they are used to make dark values. Incidentally, Winsor and Newton's vermilion and ultramarine create a velvety dark which no other brand of pigment seems to match.

Figure 25

Snow Front Moving In
Watercolor, 21½ x 29 inches
Collection of Mr. and Mrs. Frank Pechman

A thin wash of cadmium orange, grayed slightly with ultramarine and vermilion, provided color for the weeds and grass. A gray wash of ultramarine and vermilion with a little extra ultramarine formed the clouds. The same wash, but with cadmium orange added, served for the blur of tree branches catching the light. The pattern of whites was preplanned, using birch tree trunks, snow on the ground, and roofs. The darker values of the evergreen, window openings, cast shadow from the roof, and tunnel through the trees above the road were added last.

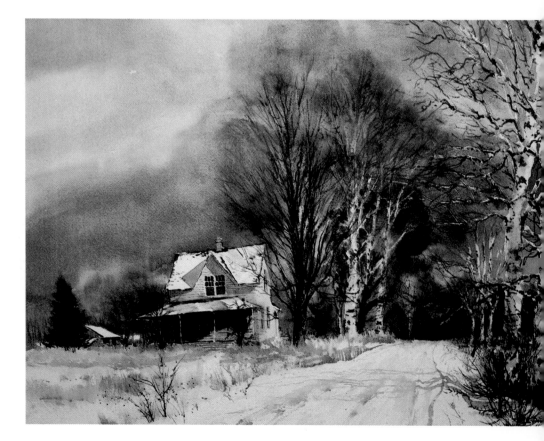

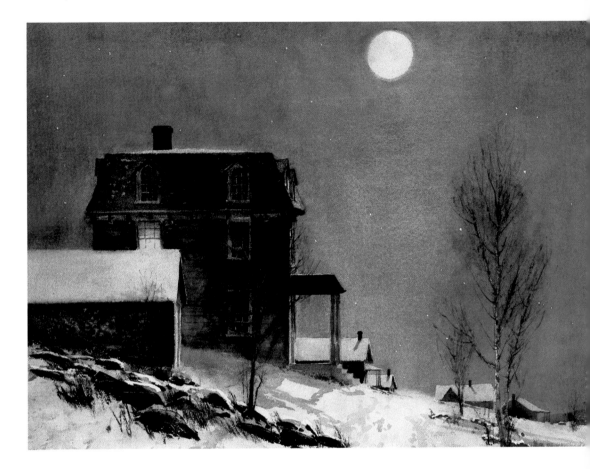

Figure 26

Cold Night
Watercolor, 21x29 inches
Collection of James Simmons

The sky was painted with a mixture of ultramarine and vermilion and darkened to the left and right ends of the sky. The stars, light on tree trunks, and bits of light on the large house were protected with liquid mask for free washing-in of this area. Cerulean with a touch of vermilion added was used in varying values for shadows on snow, both on roofs and ground. Ultramarine and vermilion created the dark silhouettes.

Value

Value is determined on a scale from black to white. It is the amount of light an object or color reflects, dark values being near the black end of the scale, light values obviously being nearer the white end, with intermediate values between (see Figure 16). Middle values usually compose the major part of most paintings with the extremes of light and dark interacting with them. Value is the key to a successful painting and frequent reference to it will be made throughout this book.

All colors have a value—that is, a place where they fall on the black-and-white value scale. Squinting at the color so that value rather than color is seen will help to determine this. Colors by themselves, without regard for value, cannot produce a good painting. The painting must be held together by a pattern of light and dark. Otherwise the result may be a "patchwork quilt" that will lack any unity or mood.

Thus if you wish to use a color like yellow or orange, for example, and it does not have a dark enough value for a particular area of your painting, you must modify that color to give it the value you wish it to have (see Figure 17).

You should plan the entire value pattern for your painting at the outset, so that your color conforms to your value plan. This is where the vermilion and ultramarine become important. You can

Cold

Hot

Melancholy

Gaiety

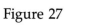

Power-Force

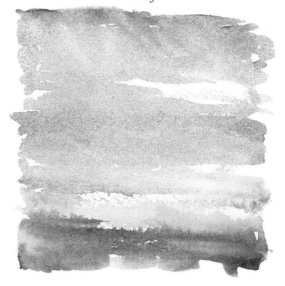

Gentle

Figure 27 *Abstract expressions of emotion without resemblance to any object*

Winter Cold
Watercolor, 21x29 inches
Collection of Mrs. Phil Austin

Details like leaning the fence post inward to relate to the house rather than the painting margin, pushing up the mound on which the house sat to make a milder repeat of the severe roof lines, a slight tone in most of the foreground to emphasize the pure white of the painting, salt in the wash on the house to create the patina of age, the casualness of the battered windmill— all contributed to the success of this painting. Basic to it all, however, is the very strong value pattern.

Figure 28

mix any value on the black-and-white scale with them; the lighter ones naturally depend on the amount of water in the mixture (see Figure 16). Since it is much easier to recognize value on the black-and-white scale than it is in the colors, you can mix any value below the middle of the scale and add color without changing the value. It is difficult to find colors which have dark value, other than earth colors such as burnt umber, but it is easy to mix as dark a value as you wish and then convert it to a red, a red-brown, a yellow-brown, a dark green, a dark blue, or a purple, as needed (see Figure 17).

Small additions of vermilion, orange, or green will take the dark in any color direction you wish, with little or no change in value, whereas the use of a strong earth color for darks will not allow a color added to it to influence the dark very much.

For colors above a middle value, the smallest amount of vermilion, ultramarine, or both will darken the value. The darker grays can easily be modified also with very small amounts of color, while still maintaining their value; a speck of orange added will make a warmer gray, a bit of cerulean will make it cooler and bluer, a bit of yellow will produce a greenish gray, and so on. We are really painting value and making our colors conform to our value plan.

Cadmium orange is a potent color and must be used *sparingly*. A little goes a long way. Should your mixed dark for some reason appear slightly purple when you wish it to be neutral, a small touch of orange will immediately remedy this. The same is true of the grays. Orange, you will soon discover, is a good short cut where normally you might add both red and yellow. Following this method allows you to make subtle changs in color and/or changes in values as you move about the painting.

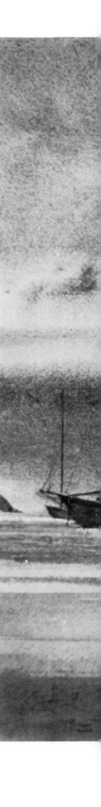

Figure 29

Harbor Buoys, Sint Maarten
Watercolor, 21x29 inches
Collection of Mr. and Mrs. Frank Mohr

This was studio painted from a series of color slides taken in the West Indies. The rain was moving in when I got the interesting sky. Several slides made up the series of yachts riding at anchor, while a shot with a zoom lens provided necessary detail for the buoys in the double ender. Being able to get a continuous variation of grays with the limited palette was important in this work.

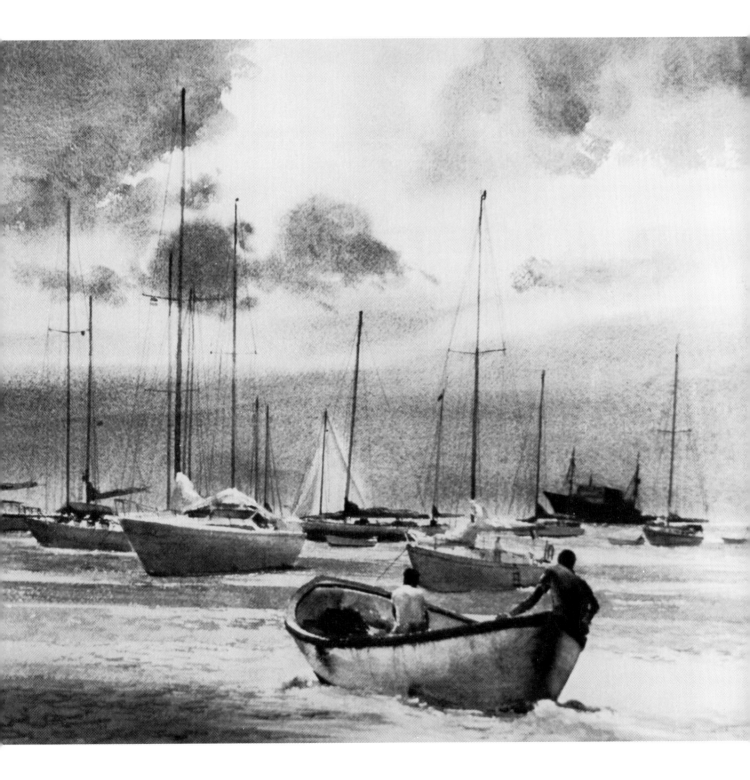

Composition—Planning Before Painting

The old saying, "You can't change horses in the middle of the stream," must have been originated by a watercolor painter. Once you are committed on a watercolor, there is seldom time or opportunity to stop, debate, or change your original plan. For that reason, it is necessary to make adequate preparation. A mental review is helpful. Ask yourself: What is my interest in the subject? What is it that I want to paint? Why do I want to paint it? Does it need to be painted? Does it stir an emotional response in me? What kind of mood does it generate? If it has been done before, have I something new to say? Does it really need to be painted again? What do I particularly like about it? What am I going to emphasize? What things will I need to change? Am I excited enough about it? Will the final result be worth the time and effort?

Center of Interest

When these decisions are reached, we need to give serious thought to the basics of composition, a must for producing a good painting.

Once you've decided what you want to paint and why, decide on a location for the center of interest. How much of the painting will it occupy? How can you emphasize it? Will you use value contrast, color contrast, or both? Will increased detail help?

A fairly safe rule is to avoid centering objects within the composition, though exceptions are sometimes valid. Placing objects off-center and varying the division of space helps toward pleasing results. Also, the grouping of objects suggests their relationships.

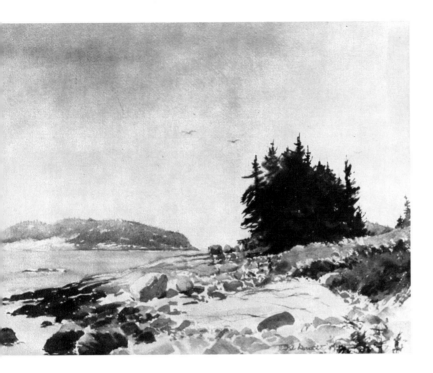

Figure 30

Incoming Fog, Shut In Island
Watercolor, 11¾ x 15⅝ inches

The contrast of warm-colored rock in the foreground, the cooler water, and the island being slowly blanketed with fog with the silhouette of pines against it was a challenge I could not ignore one evening on St. Margaret's Bay, Nova Scotia.

For example, a tree closer to a house than to the margin of the painting would suggest shelter, shade, or concealment for the house. Two figures closer to each other than to other objects in the painting would suggest some kind of relationship between them. Duplicating areas of equal size, interest, or color tends to create competition for interest. Several trees with the same trunk diameter, or placed the same distance apart, are likely to give a monotonous effect. Refraining from placing equally competing objects on both sides of a painting, choosing instead to make one smaller or more subdued in color, value, or contrast so that no comparison is invited, will also improve the composition. Varying the size, shape, and color of rocks in a wall will prevent the wall from looking like a row of bowling balls. Fence posts varying a bit in size, color, and position will be more interesting than a straight row, evenly spaced. Give constant thought to the avoidance of tedium.

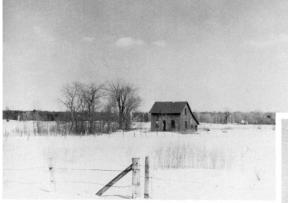

Figure 31

The location—a New England "salt box" in Wisconsin!

Figure 32

Wisconsin Saltbox
Watercolor, 11¾ x 15⅝ inches
This deserted old house in a field was an interesting subject, so I put snow on the roof, added a distant farm house, and made a rather cheerful picture.

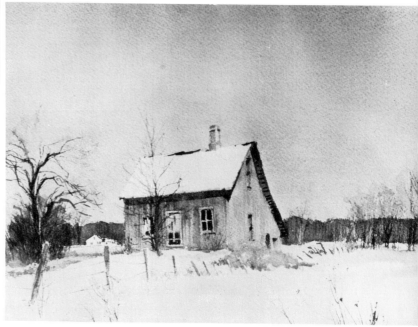

Patterns of Motion

Patterns of motion can be set up in a composition so that the subjects do not become static. There are a number of ways to do this. In a landscape, a road or a path may lead into the painting. This does not mean it should be an obvious shape—it can be a hint of a travelled area, with traces of wear, trampled grass or bits of roadway showing between clumps of grass. Tell as much of a story as you possibly can in this sort of a situation. It is never wise to shut a viewer out of a painting by placing a barrier all the way across the foreground, such as a railroad track, a picket fence without a gate, or a stone wall without a gap. Even a place where bushes or foliage can stop the horizontal motion momentarily will help.

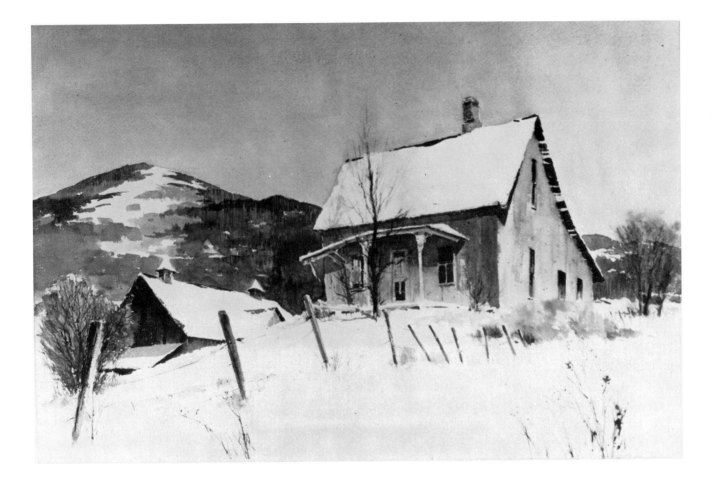

Figure 33

Neglected Dream
Watercolor, 21x29 inches

Studying Wisconsin Saltbox *I decided much more could be said, and returned it to a New England setting. I did a number of exploratory thumbnails and added the porch, barn, and mountain. Note the concentration of pure white on roofs, open fields, and on the mountain, while there is a pale wash on foreground areas. The red barn and yellow grass clumps serve as a relief to the cool grays. A light value on a fence post stands out against bushes, while another darker post silhouettes against a white roof.*

Try to bridge a strong horizontal in the foreground with some object—even if it is only a strong shadow. Use repetition of color in varying amounts and strength in various parts of the painting to create a motion pattern. Varying light and dark areas will also help.

A tree, building, or other object near the edge of the painting can serve to carry attention vertically over the painting surface. A scrap or two of blue sky in a gray overcast may then pick up the motion from the tree or building and carry it across the top of the painting to another object such as a larger tree, a telephone pole, a silo, a windmill, or perhaps a chimney on a house. From there the motion might lead to a window reflecting the sky, then on down to a horizontal puddle with reflections in it. Plan this directional pattern very carefully so that the eye will follow it involuntarily, thus "reading" the painting, and not stopping in confusion, straying out at a corner, or somewhere along the side of the painting.

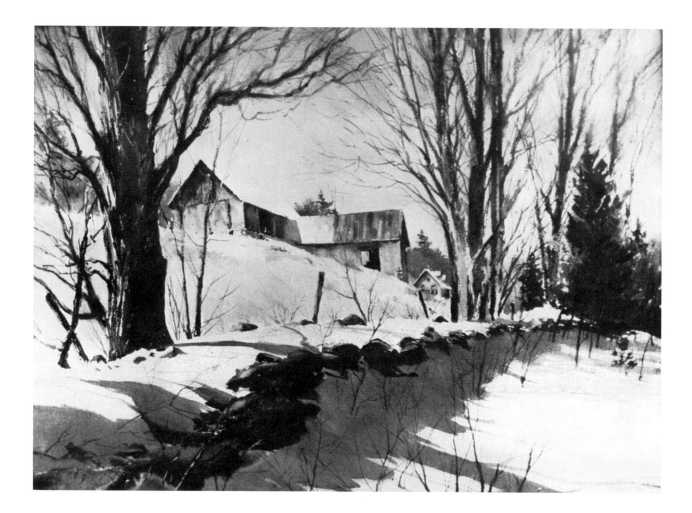

Controlling Attention

Figure 34

This directional flow needs a starting point. It could be a path into the painting somewhere in the foreground, or perhaps foam on a large wave; or light on a large rock, a clump of bright foliage, an open gate in a wall; an object like a wagon or a boat obviously moving into the painting. The possibilities are endless. Sometimes an object of particular interest can start that motion within the painting and the various ways mentioned may be used to keep it circling.

Farm on the Winter Hill
Watercolor, 21x29 inches

A beautiful, snow-covered stone wall prompted this studio painting. The strong values of rocks and shadow with adjacent trees hold the attention while more distant buildings and wood create the atmosphere. In color, the foreground is cool. A hint of yellow grass on the hill, a rusty orange roof on the lower barn, and warmth in the distant woods give the feeling of sunshine.

Areas of contrast will also draw attention to different parts of the painting and establish the motion pattern, silhouetting dark objects against light or bright color against dull color. Action in the painting will also accomplish this.

Corners of a painting need special attention, lest they draw too much interest. You will do well to avoid the use of any strong line coming directly to a corner, which unavoidably draws attention to it. We can deepen color in a corner (see lower left and right in Figure 35), reduce details, or in some instances use a light corner as lower left Figure 189, which picks up the motion from other light areas in the painting. Sometimes a large simple object which breaks out of the picture, such as the boat in Figure 35, can effectively close up a corner.

When an awkward dead space occurs between an object and an edge of the painting it's a good idea either to get rid of the space by moving the object into it, or to enlarge the space by moving the object away and thus toward the center of the picture. Should you make the former choice, the object can even be cropped by the picture's edge, but be sure that enough of it remains for it to be identified. In the case of the latter choice the formerly dead space will become a valid shape that takes its place in your composition.

Placing objects where edges just touch causes obvious contact points, while coinciding lines of different objects may create awkward areas, which attract unwanted attention.

A painting that is abstract in character can rely purely on shape for composition, whereas a representational painting relies on recognition of those shapes, as well. For this reason if part of an object—a wagon wheel or a barrel, let's say—should extend outside an edge of the painting you must make sure that what remains is not only a pleasing shape which fits your composition, but also identifies itself as a wagon wheel or a barrel. When this is done successfully the viewer supplies the missing part of the object with his mind's eye.

A painting can be like a good mystery story. You enjoy the story only if there is enough suggestion to allow you to search for your own conclusions. Even though your conclusions may not be the ones the writer finally supplies, you will be stimulated in your pursuit and may even enjoy your own conclusions more than the author's. Similarly, you as an artist can remind the viewer of a pleasant experience or an area he has enjoyed without spelling it out completely for him. Nostalgia has the power of wonderful recall.

Singleness of Purpose

When planning a composition, it's necessary to stick to your first impression or intention and not allow yourself to be distracted. If other ideas intrude, make a note of them and perhaps set them aside for another painting at a later date. In the beginning this is hard to do. It is natural to include too much, and add meaningless frills. Constantly remind yourself to restrict your efforts to the single most interesting thing you have in mind for your painting. One of the values of a sketch book is that all exploratory thumbnail sketches are there, available for future study. They often yield entirely new ideas, other than the ones originally pursued.

Figure 35

Waiting to Unload, Kotzebue
Watercolor, 15x40 inches
Collection of Mr. and Mrs. Delbert Hargrave

This painting, an ambitious use of figures, had to be made with slides taken on an August evening above the Arctic Circle. Darks are very carefully accented against light areas. The largest group of figures dominates the center of interest. Simple boat shapes contrast with figures and shimmering reflections. A high skyline was used.

Viewpoint

Early in your planning a point of view must be established. Should you be looking up to the main object of interest, or down into it? Will you use a low horizon with very little foreground and a great deal of sky? Or would it be better to break objects out of the top of the painting and use a predominance of foreground? Your whole arrangement of the composition depends on your choice at this point. This is where several quick thumbnail sketches can be of great help.

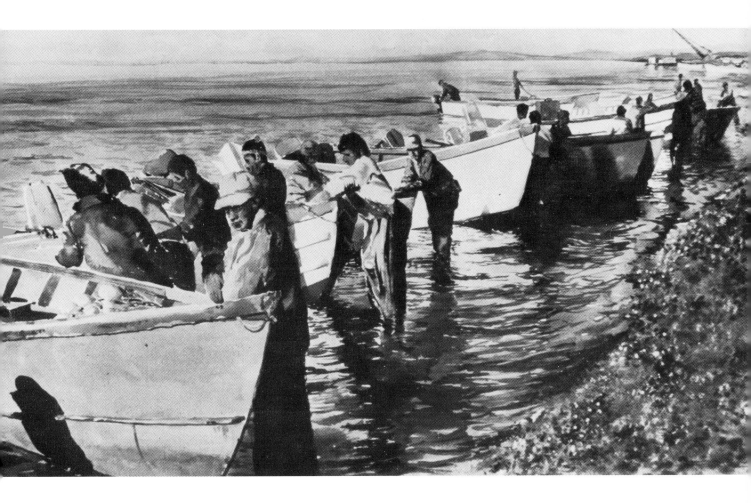

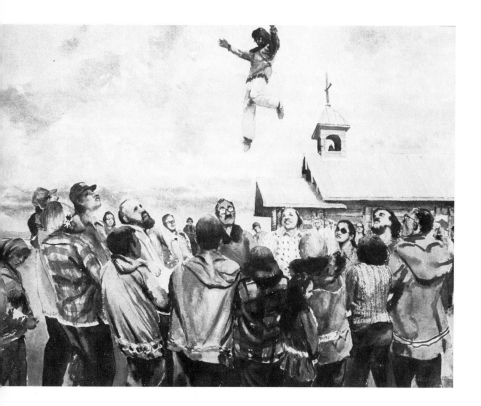

Figure 36

Blanket Toss, Kotzebue
Watercolor, 21¹/₂ x 29¹/₂ inches
Collection of Mr. and Mrs. Leon Zigmun

*In this painting everything is intended to
emphasize the flying figure. The clouds form
a triangle of tone creating an area of light
behind the boy in the air. All figures pull
away from the blanket in the center, all eyes
are on the figure in the air. The upraised
hand breaks the top margin to suggest
height. The church is simple in detail, as are
all surroundings, so that the story is simply
and directly told.*

Direction of Light

You must also determine the direction from which light is falling
on your subject. Should you look for back lighting, flat lighting,
side lighting, or shadowless lighting? This is an important choice.

A subject which does not draw a second glance will, at another
time, in a different light, become an exciting scene to paint. Paint-
ing on location offers you the opportunity to observe the impor-
tance of the lighting. If you have the time, an excellent idea is to
check out painting areas at different times of day under different
weather and light conditions. Thus you can develop the habit of re-

Figure 37

Pennsylvania Hills
Watercolor, 21x29 inches
Collection of Mr. and Mrs. Boris Dudchenko

*This painting has a high viewpoint, looking
down and out into the hills. Nearby fence
posts and buildings in the middle ground
give scale to the distant countryside.*

viewing lighting possibilities, so that when you plan a composition you can make the best choice.

You might even get a detailed map of your particular painting area, mark favorite spots, make notes as to when lighting is best, what season is best, what weather conditions are most exciting. Then plan your painting trips to take advantage of these facts.

An example of this is the painting (Figure 202) of an old limestone quarry. Planning to do it on a sunny, snowy day, I drove twenty miles, only to have dark clouds move in. However, the subdued light had given it soft color, subtle values, an air of mystery, and a mood which was far more exciting to paint than the harsh light and strong shadows of a sunny day.

Figure 38

Down to the Beach, Brookings, Oregon
Watercolor, 21x29 inches

This subject was a real challenge in perspective. It was achieved by the reappearing stairs which diminish in size, elimination of a horizon, and diminishing brightness of color as cliff and foliage receded. The focal point was obtained by a very strong dark next to the brightest area of the beach.

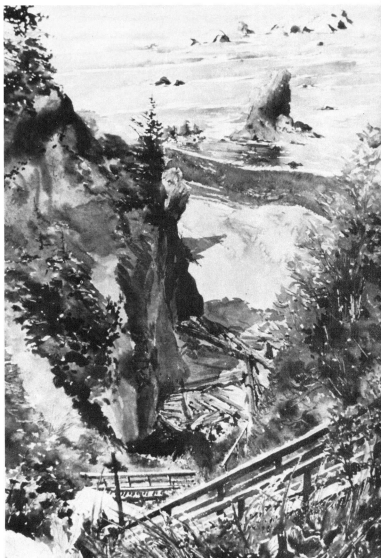

Back Lighting

Figure 39. *Value study for a dramatic use of back lighting, using morning light.*

Figure 40. *Basis for soft backlight, an evening painting, using sky reflections.*

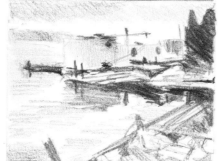

Figure 41. *A lad sitting indolently watching the Baja surf, creates mood of area.*

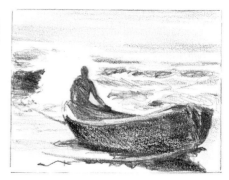

Side Lighting

The twelve following thumbnail sketches demonstrate the various kinds of lighting. Figure 39—Backlighting gives us dark objects against light surroundings. Boat piers and pilings form an interesting dark pattern against almost pure light used as negative space. Figure 40—Again uses a boat, piers, pilings, and fishing equipment, as well as a distant headland of lighter value, backlighted by a bit of evening sky, and its reflection. Figure 41—A boy sitting on a beached boat, also shows an interesting silhoutte against lighter distance and surf.

Figure 42—Uses flat light which often results in light objects against a darker background. Figure 43—The main street of Sitka, Alaska, places buildings flooded with afternoon light against a dark mountain. Figure 44—Farm buildings and foreground pick up light with darker trees flanking them.

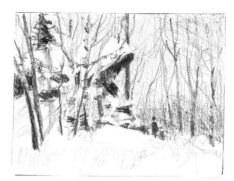

Figure 42. *"The King's Hat": rock escarpment, snow-covered, with morning shadows.*

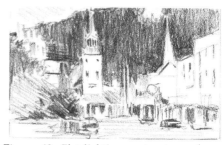

Figure 43. *Flat lighting creates strong design of light against dark for painting.*

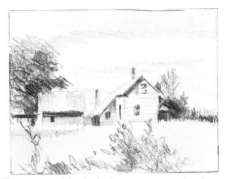

Figure 44. *Flat light here creates a simple, less dramatic pattern for painting.*

Flat Lighting

Figure 45. *Sketch using side lighting for the painting* Hahn's Peak Village. *Page 158.*

Figure 46. *Long shadows of side lighting move rapidly. Make notes, memorize.*

Figure 47. *Strong side lighting up in front, repeated in distant light and dark.*

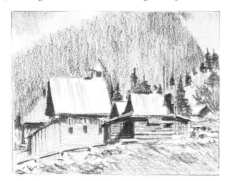 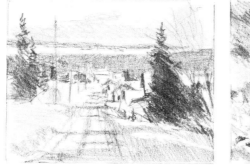 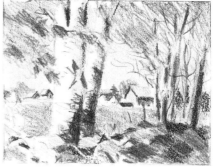

Shadowless Light

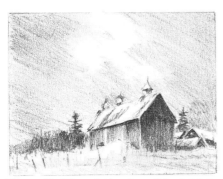

Figure 48. *The painting from this sketch is analyzed fully on page 164.*

Figure 49. Morning Silver at Rowley Bay *is shown on page 176.*

Figure 50. *Soft color and a glimmer of light on water create interest. See page 194.*

Figure 45—A Colorado mining town shows the effect of strong diagonals from side lighting, combined with some top lighting. Because of the inclined surfaces, the roofs catch strong light. This type of light generally provides strong patterns.

Figure 46—Shows the use of strong shadows created by the low side lighting of winter months.

Figure 47—A farm scene shows side lighting picking up scattered lights and creating darks as well. Shadowless light creates much more subtle compositions with fewer strong contrasts.

Figure 48—A barn and winter orchard provide opportunity to use large simple areas of value.

Figure 49—A late fall scene depends on values of objects to create the pattern as does Figure 50, the sketch for a painting of a tide marsh. Figure 20—The old limestone quarry referred to earlier also demonstrates this type of lighting used to make a successful painting. Moody paintings are very likely to require shadowless light.

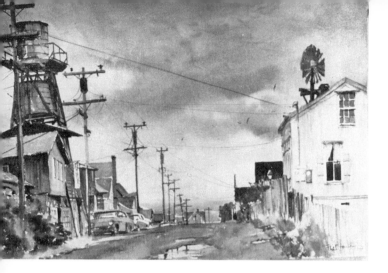

Figure 51

Rainy Alley, Mendocino
Watercolor, 14½ x 21½ inches
Collection of Dr. and Mrs. Paul Swade

Puddles and a spot of clearing sky (negative space) tell the story of lifting weather. The complex pattern of surrounding poles, water tanks, windmill, and buildings is held to a series of relatively simple value contrasts, the darkest spot being roof silhouettes against the light sky. The puddles suggest the recent rain, adding interest.

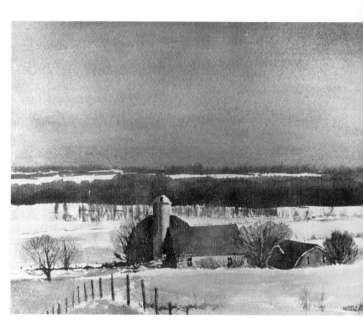

Figure 52

Winter Valley
Watercolor, 11¾ x 15⅝ inches

The curving line of fence posts was used to lead the eye down into the painting on the left. The pattern of trees and overlapping farm structures carries the interest across the painting and eventually the long, slightly angling horizontals lead back and forth and up into the simple sky area.

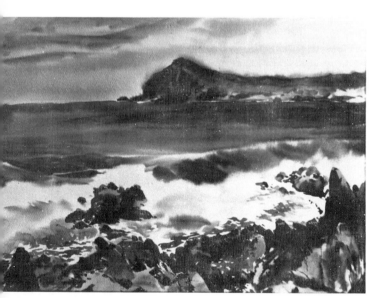

Figure 53

Whaleshead Point, Baja, Mexico
Watercolor, 21x29 inches
Collection of Mr. and Mrs. Gordon Stow

This painting uses wet edges to create motion in the wave. Change of value in the surf area creates shadow and form, while little chips of color create the turmoil in front of the wave. The jagged rocks accentuate the action.

More about Value

We considered value at some length earlier. Now let's consider the influence of value on composition.

Values are a powerful design factor. If you fail to consider values as you paint, your work is likely to either be flat and drab, or become areas of vibrating color. If you are painting a building in bright sunlight, regardless of what color it is, the side towards the sun will be considerably lighter than the side away from the light.

Such value differences add depth and dimension to the objects in your painting. Without value contrasts the forms in the picture will appear flat. The more you plan and exploit the use of value contrasts, the stronger the feeling of form and depth on your two-dimensional painting surface and the greater the illusion of reality.

Generally the greatest extremes of value occur in backlighting situations such as the example on page 54. This can produce dramatic effects. Under the usually prevalent conditions of side lighting, the forms can be delineated in many interesting ways. Diagonal shadows can show changes of plane and establish exciting compositional shapes. Strong contrasts between the light and dark sides of buildings create the feeling of solid forms. Reflected lights can be used to lighten areas and create interest in the shadows.

Variety in value will be present also in flat lighting of subjects, but in a lesser degree. Contrast in value is effective in separating the principal subject material from its surroundings. A deep cloud shadow or a dark sky behind an object such as a building will highlight it even though the painting has flat lighting (Figure 54).

Figure 54

November at Spring Mill
Watercolor, 21x29 inches

This marvelous old stone mill with its twenty-four foot overshot wheel has been reconstructed in an Indiana state park. The sluice with its stone pylons, the sawing platform in the foreground, and the filigree of tattered sycamores provide a beautiful contrast to the simple block of the mill. I have painted it several times under varying conditions.

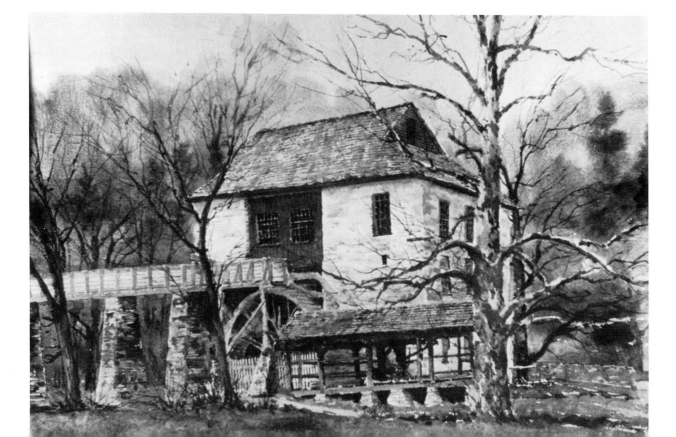

Varying the contrast between values can add emphasis to any area of the painting. Figure 52—A large flat sky of medium value, very limited ribbons of pure white snow, and varying small areas of detail would be less emphatic than areas of strongly contrasting values. Again, extremely different values, a large amount of light area, some smaller extreme darks adjacent to it, and the balance of the painting handled with medium values, highlights the center of interest, Figure 51.

Working with small sketches, either pencil thumbnails or watercolors, gives the opportunity to experiment with value ideas until you find the most effective way to use them in any particular subject you are planning to paint.

If you find that you are experiencing difficulty determining the value of a particular color when painting on location, try using an inexpensive "instant" camera with black-and-white film. The resulting print will tell you at a glance what value to give that particular area. You may decide to change the color somewhat and increase or reduce its value as well. You may find it helpful at times to photograph your finished painting in black and white so that you can more readily analyze your values.

One important thing to remember is that you are not a camera, accepting colors and values as they are, but are free to manipulate and adjust value and color to your advantage.

Color

Keep in mind that colors have both hue and value. Some colors appear very light, others medium in value, others dark. The value of a color can be changed, not by making the color richer—more intense—but by adding other color to it (see page 33). A yellow which appears too light in a painting can be deepened by adding a little bit of orange. Adding a minute amount of ultramarine will deepen it further, making it slightly brown in hue. A little more blue added will make it deeper in value and slightly olive green in color, as yellow appears in shadow.

Another example: adding a very small amount of vermilion to ultramarine at the zenith of a sky in your painting approximates the darker blue seen directly overhead in nature. Green, with some ultramarine and vermilion added, becomes less bright in hue and darker in value, which is exactly what happens when a shadow falls across it. Since with the limited palette you plan first for value, then for color, as described earlier, you will establish the value by mixing ultramarine and vermilion to make colors of medium or lower value. Should you want a number of areas of different col-

Figure 55

Against the Sky, Key Largo
Watercolor, 14 x 21½ inches
Courtesy of Gallery One

This old yacht, rusting and rotting on the ways, caught my eye, its neglect contrasting with the work being done on its neighbors. The mottled sky and blowing flags describe the day. A careful thumbnail study was required to determine the correct values. (I later learned that this boat was seized running dope, and that its future was almost certain to be oblivion.)

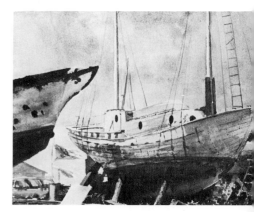

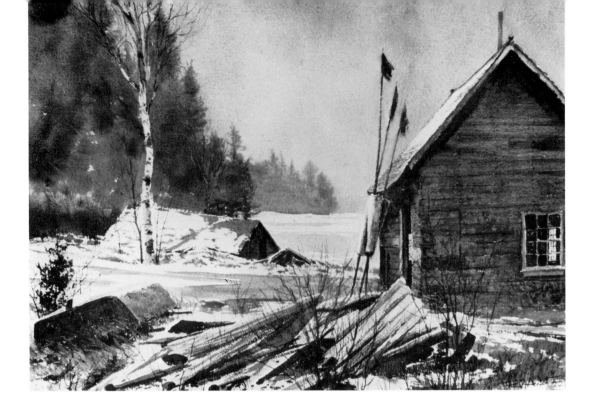

Figure 56

Winter at Olson's Dock
Watercolor, 21x29 inches
Collection of Peggy Cox

Dark values were used very carefully to create a circular motion within this painting. The building, being largest, gets first attention, next the pile of lumber, then the stern of the over-turned boat, then the cedar shrub. The light birch on the left increases the upward thrust. The evergreens continue into darker sky carrying the motion across the top, then picking up the marker flags, and coming back to the starting building.

ors to remain uniform in value, you can mix the desired value with ultramarine and vermilion and add the approximate colors to reinforce each area. Thus your value will remain constant as you change color—an excellent way to pull the painting together!

Before trying this method on a painting, do some experimenting on student grade paper until you become familiar with what mixtures are required to get the values and colors you're looking for. The more you use the limited palette, the easier and more natural this way of working will become. You will find greater flexibility in handling values. Colors in the higher or lighter range of values such as yellow, normally will be used pure (diluted only with water), while slight deepening of value will be achieved with the addition of a little other color, as we mentioned earlier. To repeat, for middle values and below, you will wish to mix value first, then add color.

This method is demonstrated in a bright yellow-green lawn in full sunlight (see Figure 23). Yellow with a little viridian added creates the sunny area. Here and there a bit of ultramarine gives a slight feeling of shadow, suggesting unevenness of surface, with a casual deepening of color. Where a shadow falls across the lawn from a tree, it will obviously not be a light green anymore, so ultramarine and vermilion is added to make it appear green, thus achieving value and color at the same time.

Positive and Negative Space

Negative space is frequently thought of as the unpainted areas of a painting, forming a loose vignette around certain parts of the painting (see Figure 57). This way of handling composition is but a part of what negative space can do for a painting. Since it is inactive space, it must be kept simple, containing no strong contrasts or elaborate detail. It must be planned together with the positive space which constitutes the objects of greatest interest. Positive space is "where the action is."

A good example is Figure 58, a painting with a simple sky area—negative space. Its size and shape are very important to the painting even though it is negative space. By way of contrast, observe Figure 29, a painting in which the sky is primarily the center of interest with exciting clouds, a good deal of texture, changing values, and a lot of action. This sky is positive space. Negative space is a quiet area in contrast with the very active and exciting parts of the painting. This contrast of areas is important.

A painting with a lot going on would not require a busy sky. Similarly, intricate buildings in a painting would necessitate a simple foreground. It is important that the use of space be planned carefully in advance. It just does not work to plan and paint an area of interest and figure to "use the space around it, someway."

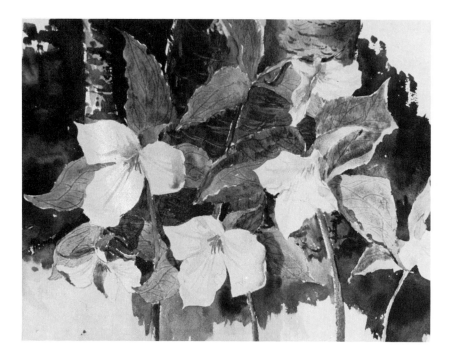

Figure 57

Spring Trillium
Watercolor, 11¾ x 15⅝ inches

The white vignetted corners of this painting relate to the white flowers so that they do not float in a sea of dark value. The leaves provide an intermediate step between areas of extreme dark and light. A faint wash in some of the vignetted area sets it apart from the pure white of the flowers.

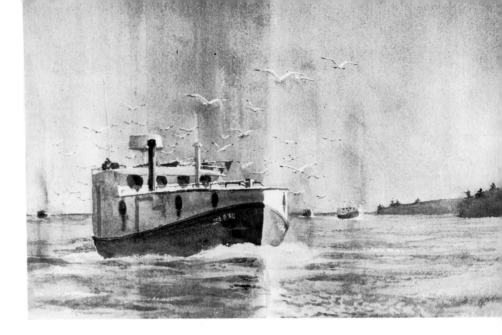

Figure 58

Returning Gillnetters
Watercolor, 14x21½ inches

In this painting, although the large sky is used as negative space, its simplicity is relieved by a gradual deepening toward the zenith and by use of vertical brush strokes related to each fishing boat as well.

There are times when, by its position and use, negative space becomes the center of interest (Figure 59). This painting of Southwest Harbor on Mount Desert Island, Maine, with rain softening the details of the landscape, has negative space beginning in the foreground with only small supporting details of rocks, pilings, and boats. It carries up through the composition to include faintly visible land in the far distance. The emptiness, loneliness, and lack of activity caused by the steady downpour would be lacking were large detailed lobster boats present in the foreground.

Overlapping

Harmony of composition is maintained by interlocking areas of interest into a logical pattern rather than leaving objects scattered all over the painting. By overlapping shapes it is possible to avoid this kind of discord. A further function of overlapping is to give the illusion of depth, causing objects to appear to recede from the eye of the viewer. By placing a tree partially in front of or behind a building or another object, or by carrying a foreground shadow across an empty area and up the side of a building, tree, or slope, we can overlap to strengthen the composition. Explore all possibilities in the thumbnail planning stage, even to the extent of considering whether the clouds will be overlapped by trees, buildings, or mountains. Plan the overlap of open areas to create a more interesting use of negative space as well.

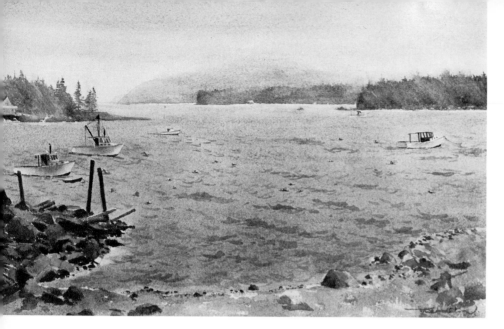

Figure 59

Rain at Southwest Harbor
Watercolor, 13-3/4 x 21-1/2 inches

The mood was really strong as I sat in my van staring out into the rainswept harbor, running the wipers occasionally and painting all the quiet and solitude here on Mount Desert Island, Maine.

This principle is found in the painting of Jackson Harbor (Figure 61). Dry marsh grass in the immediate foreground overlaps the negative space of water and the rowboat. The boat overlaps the dock. The dock is overlapped by the fishing boat tied at the end of it. This fishing boat, a "gillnetter," overlaps a distant one. Old pilings and a light pole on the dock overlap more distant water (containing reflections), the farther shore of the inlet, and a log dock and fish sheds. The two gillnetters tied up to the distant dock overlap that dock, a fish shed, the distant shore, and a bit of sky. You will find it a simple matter in the early planning stage to move things around to interlock in this manner. Do this in the beginning, lest you end up with objects in an awkward place resulting in very poor composition.

Figure 60

Calm Passage
Watercolor, 21-1/2 x 29 inches
Collection of Mr. and Mrs. Patrick Riley

The cloud-draped mountains along the Inside Passage of Alaska provide an example of the depth which can be created by overlap. The calm water and reflections double the effect. This painting is composed almost entirely of varying washes of gray blue, the green nearby point and the green islands being the only exceptions.

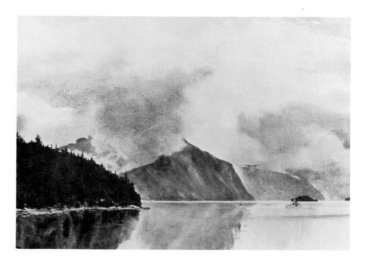

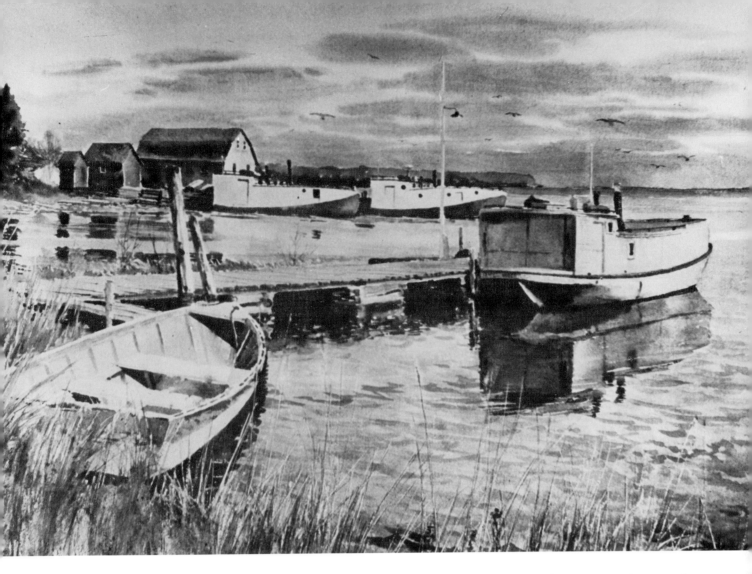

Figure 61

Cold Moving In, Jackson Harbor
Watercolor, 21x29 inches

This little harbor on Washington Island off the tip of the Door Peninsula provides a wealth of good painting subjects. In this painting looking out toward Lake Michigan, Rock Island lies on the horizon silhouetted against a cold wet-on-wet sky, creating a very definite mood.

Depth in a painting is further emphasized by reducing the size of more distant objects, by reducing the intensity and value contrast of color, and eliminating distant detail. In addition, a slight reduction of value at the points of overlap (see Figure 60) creates a feeling of atmosphere (space between overlapped objects).

Overlapping can delineate terrain in a landscape, as well as contour of an object. A shadow falling across an object will show clearly the ins and outs of the surface—like a log wall for instance, or a rugged rock. In a landscape, note this use of shadow in "From Plateau Road" (see Figure 62). Wildflowers in the foreground are detailed. Then trees begin a series of overlaps, reducing in color and value as they recede into the landscape. Horizontal shadows follow the flowing contour of the land. The little cluster of farm buildings has a minimum of detail, as do the distant fields and hills.

In a painting, a road going over a series of rises and hollows illustrates a simple use of overlapping to describe the topography. Here the road reappears, narrowed because of distance, and is overlapped by the wider portion of the road in the foreground.

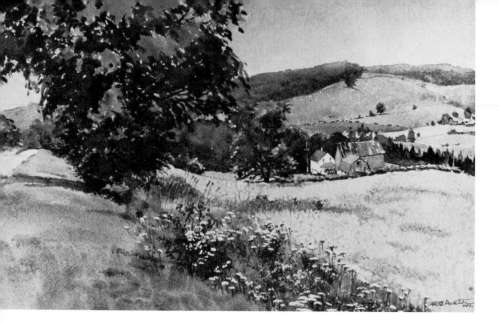

Figure 62

From Plateau Road
Watercolor, 13¾ x 21½ inches

A favorite spot of mine, the peaceful rolling countryside of Door County, Wisconsin, where I live.

Lost and Found Edges

Light is the most important factor with which an artist deals. God has given us a beautiful world, but without the gift of light, we could never be aware of that beauty! Where there's no light there's neither color nor variation in value.

An aspect of light and what it does that is important for successful painting is its effect on edges. Light or absence of light, as the case may be, creates lost and found edges. Recognizing and using these in our painting will give our works a fluid quality.

Taking into consideration the direction from which light falls, you will see that all surfaces receiving it are light and those not directly receiving it are to varying degrees darker. In a painting as in nature, the edges between adjacent or overlapping light-struck surfaces are often lost due to the overall uniformity of value. The same holds for the darker surfaces that are close in value. This is often true regardless of local color.

Lost edges can help tie a composition together by unifying areas, making a single large shape out of several smaller ones. This is a phenomenon you can observe in nature by squinting your eyes as you look at a group of objects in a landscape or still life.

Figure 63

Dock at Bayfield
Watercolor, 21x29 inches

This painting clearly demonstrates lost and found edges. Boat hulls blend with reflections, light flows from dock over to light deck areas, light values of fish shed blend with similar areas as do the docks. The figures of fishermen blend at some points, contrast and stand out in other areas, contributing to a fluid painting.

Every time you eliminate an edge where areas of similar value are adjacent you take another step toward tying the composition together with a fluid passage. It's natural to try to avoid allowing colors to run together. Yet when you study nature, you see all kinds of surfaces and objects that blend together. In fact, when you strain your eyes to separate these areas, you often cannot do so. You can employ these lost edges to create interest, mystery, and flow. Just as you enjoy reading a story where the writer does not bore us with every minute detail, but allows us to use our imaginations to fill out his story, so you want to allow the viewer of your paintings to create his own story (see Figure 63).

As you need lost edges, so you also need sharply defined or found edges. These occur where very different hues or widely separated values meet. They cause a pleasing contrast to the lost edges and give the painting necessary definition. Watercolor painting offers every opportunity, because of the nature of the medium, to be fluid. If you fail to make the painting flow from one area to another because all its parts are too sharp and distinct, you'll have missed the whole reason for doing the painting in watercolor. Many failures are due to a lack of knowledge of lost and found edges.

Increasing Contrast

Aldro Hibbard, an outstanding New England landscape painter, once suggested to me that "a surface is never the same from side to side or from top to bottom." He reasoned that any object or surface is always subject to varying influences such as sky light, reflected light, change due to contrast with some other hue or value, or change in value due to its shape. He further stated that if each surface was a continuous uniform hue or value, all the excitement that exists in nature would be lost. Learning to incorporate this into your painting habits will improve your work immeasurably. It will lead you to increase contrast at times, change color within an area with or without a change in value, observe and record reflected light or color, and become more aware of the influence of light.

In Figure 64 the painting of the old farmhouse demonstrates both lost and found edges and changing values. The tawny grass in the foreground changes somewhat in color, and even more in value. It is light against the dark pockets of shadow in the rock wall, darker against the light flooding the top of this wall, equal value in some places with the rocks, and lighter, forming a lost edge where it meets the light on the left-hand side of the building.

The slanting porch roof lightens toward the left as it meets the darker shingles of the front wall. The roof on the wing of the house gradually becomes deeper in value toward the left as it meets the cloudy sky, but goes lighter as it meets the other roof, creating a lost edge.

Figure 64

Norma Jean's Farm House
Watercolor, 14x21½ inches
Collection of Mr. and Mrs. Vincent Shiel

The interior of this old house has a charm which matches the simplicity of the exterior. It reflects early Door County.

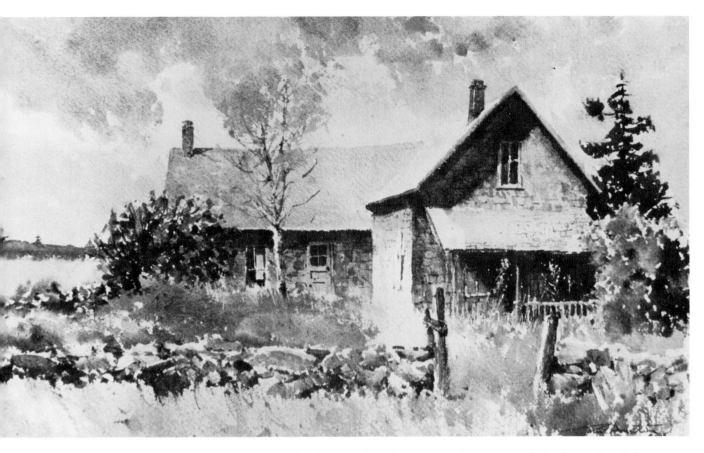

The shingled walls of both the wing and the left side of the main structure deepen in value gradually as they approach the shadow below the eaves, forming a very strong found edge at the eave line. The bushes at the left of the house darken against this wall creating a lost edge, but the bushes on the right create a found edge against the deep shadow under the porch roof, as well as against the dark green of the pine behind them.

The fence posts at the opening in the wall deepen as they go upward to create a found edge at their tops. The light on the left side of the two left posts creates a lost edge against the light grass, but another found edge against the darker shingles of the house. The clouds in the sky change value, going pure white against the roof on the farmhouse wing, but light gray to be lost against the other roof. You can examine this even further in the painting for yourself.

The treatment of edges can be used to great advantage in establishing centers of interest, in making little sparks of contrast, in creating excitement and a flow of light and dark values throughout the painting.

In Figure 65, an early morning painting at Port Salerno on Florida's east coast, the use of extreme contrast through changing value to create the glare of morning light is demonstrated.

Additional Analysis

Figure 66—"Afternoon Light at Indian Harbor," a Nova Scotia painting, demonstrates clearly the principle of changing value in various areas to build contrast and center of interest. The light-splashed areas on parts of the boat in the foreground, such as the seats and brackets and the gunwales, are extremely light while shadows are extremely dark, especially under the rear seat (lightening upward along the rib structure), and in the center area between seats, as well as the near side of the boat beneath the gunwale and bow.

Notice the changing value in the large rocks behind this boat. The nearest fish shed darkens toward the right as it approaches the lighter area where the men are working. The light floods on the dock around them. Their silhouettes, as well as the table, barrel, and dock, seem to increase the intensity of this flood of light, by contrast.

Even the distant sheds darken upward to emphasize the light area below them. The distant rocks are very light, but the distant seawall darkens gradually toward the right, away from the area of extreme light. Decks of anchored lobster boats pick up bits of pure light as well, to contrast with deeper shadow areas of interiors and water lines.

The water itself is almost without color or value near the dock, but deepens gradually toward the right. The lower left front corner of the painting has dark gravel tones in contrast with lighter grass beyond it. Even the sky deepens in value to the left and right of the center of interest. All of the above-mentioned touches bring interest into the area where we wish to center it. This should be done in such a way that it is effective without being obvious.

Figure 65

Morning Glare, Port Salerno
Watercolor, 14x21 inches
Collection of Mr. and Mrs. Gerald Slade

The far side of the inlet was deliberately eliminated to increase the feeling of light. The color of the water gradually fades out, as well as the indication of wavelets, towards the top of the painting. The verticals of pilings gain in intensity of value as they silhouette against the light, increasing the contrast. The light surfaces of dock, cabin top of the right-hand boat, and gunwales on all three boats become almost invisible lost edges in some places, but gain by contrast in other areas. In general, the darks are not as strong down in the body of the painting, so that interesting details of the interior of the boats can be seen. Numerous little areas of extreme contrast may also be found, the equivalent of black against strong light, adding excitement to the painting.

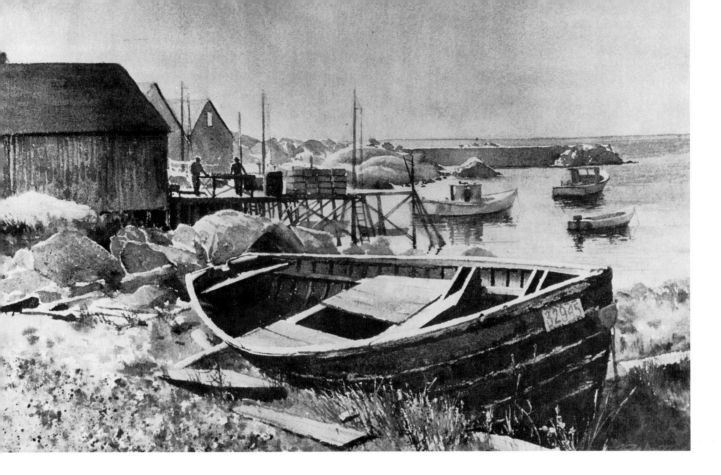

Figure 66

Afternoon Light at Indian Harbor
Watercolor, 14 x 21½ inches

Because of the importance of holding delicate light such as grass against the boat hull, bracket edges, light surfaces on rocks, figures etched in light, chips in paint, with many of the above in sustained areas of wash, it was convenient to use liquid mask before flowing on large areas of wash. While this painting is predominantly composed of values of gray, subtle color added to these washes give it interest.

Putting It Together with Thumbnail Sketches

It will help to write ideas down so that you have a clear purpose before you start planning a painting. Then begin to make thumbnail sketches with a soft pencil on the smooth paper of the sketch book. Because the paper is smooth and the lead is soft you can easily experiment, darkening values, lifting others with a kneaded eraser, and moving objects until you are satisfied.

Decide at this point how much you want to include, what you will leave out, whether the format of your painting will be a conventional rectangle, a vertical, or a horizontal, or if a square or a circle would be better. Because these sketches are small, usually no more than 3x4 inches, you need not get involved in a lot of drawing. You will be working mainly with ideas, smudging here, softening there, sometimes moving the margins of the sketch, studying values and use of space.

Try different arrangements, doing several trial sketches until you are satisfied you have worked out the best composition possible, one that will emphasize the main theme of your painting in the

simplest and most direct manner. Figure 67 shows a group of these thumbnail sketches.

In doing this planning you will have also imbedded in your mind a sort of mental blueprint of what you intend to do. You should also be considering what procedure you will need to follow, what areas to paint first, and whether to paint light or dark. You will have to time your return to some areas so that some edges will run slightly together while others will remain separate.

You might make some notes to remind yourself of procedure. You will also have to decide how you will handle the subject: wet-on-wet, limited wet areas, dry brush, a wet approach on dry paper with a loaded brush, or a combination of these. Also you will need to decide what type of paper will work the best—rough, coldpress, or smooth? A given texture may lend itself particularly well to one type of subject, but not to another.

Final Drawing

It is important to make your thumbnail sketches conform in scale and format to the intended painting. Once the final thumbnail sketch is chosen, there is a simple way to translate it to the sheet on which you intend to paint. Since it is often difficult to begin to draw objects in correct size and location on the large sheet, you should avoid a trial-and-error procedure which not only wastes valuable time but frequently damages the painting surface through erasure. You can use an artist's proportion scale, available at art stores. This consists of two calibrated discs riveted together at the center so that they can revolve (Figure 68). If your sketch is 3 inches long and your painting is to be 29 inches long, set the discs at 3 and 29. Then any other comparisons made will be in proportion. For instance a measurement of 1 inch will be 9¾ inches on the large sheet, 1½ inches would be 14¾ inches and so on.

Plot a half dozen or more key points from your thumbnail sketch on your painting sheet and place light pencil dots at these points. They might indicate the horizon height, or the two ends of a roof of a building, the main corner of the building, or the placement of a tree (see Figure 69). This assures an accurate start so that you will not end up with a boat or a building smaller or larger than you intended, or too far from one side of the painting so that you have more space than you can use at this point. If some other areas or objects give you trouble, simply plot a couple more points to work from.

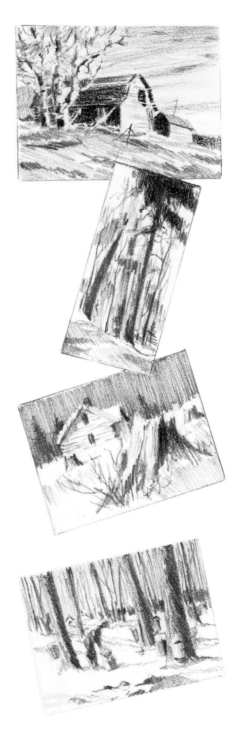

Figure 67

Figure 68

The proportional scale shown above was used to plot key points in the composition from a thumbnail sketch as shown in Figure 69.

Now you will find it easy to draw in all other items in correct scale and position. You have a painting guide and you are off to a good start. Many paintings which could have been good end up as disasters because the drawing was not true to the original plan and the artist, rather than start over, elected to go ahead and "think of something" to fill in extra space! Second guessing is painful.

The amount of drawing before painting will depend largely on the subject material. If buildings are involved, make sure the perspective is correct, then indicate large areas such as roofs, walls, and the like. If there are distinctly individual details that you want to preserve, such as dormers on a roof, log walls, where a shadow falls, or the angle of light, indicate these lightly. Rough in tree shapes for size, and position stone walls, fence posts, and such.

If boats or ships are involved, you will need to spend more time in drawing, since subtle lines of gunwales, bows, sterns, rigging, gear and many other details are important in correct portrayal. If you intend to use large figures or animals, you may find it helpful to draw them first on tracing paper to get correct size and convincing action. Then you can experiment as to the exact place to locate them in the painting. They can be transferred with a graphite sheet. (Do not use carbon paper since it leaves a greasy line which will not receive watercolor.)

These little thumbnail sketches suggest the searching process that leads to good value and composition.

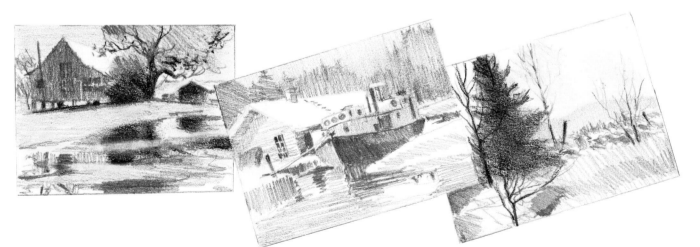

Emotion

Figure 69

When you look at a painting, does it arouse emotion, pleasure, nostalgia, fear, excitement, happiness, melancholy, peace, turmoil, or does it leave you completely apathetic? When someone views your work will it arouse an emotion or will it leave him or her indifferent? If emotional reaction to a subject prompts us to paint and we convey that emotion in all honesty, our painting becomes "us." We are then sharing ourselves with others. Watercolor is an exceptionally good medium to convey emotion and mood, particularly if it is used in a fluid and spontaneous manner.

There are a number of things which will help to express feeling. Choice of color or combination of colors is important. Direction of stroke, softness or hardness of edges, values, amount of contrast—each plays a role in expressing an emotion. An excellent way to learn is by trying to express abstract ideas with a brush without any indication of a recognizable object (Figure 27 on page 40). We have spent a two-hour period doing this type of exercise in my workshop classes. We use a list—usually of opposites—such as hard, soft, sweet, sour, quiet, noisy, happy, sad, cold, hot, powerful, weak, rough, smooth, disturbing, peaceful, and so on. They are done one at a time, confining each effort to a four-inch square. The students have five minutes in which to think and do it. It seems difficult at first, but with a little practice the ideas begin to flow. It's particularly helpful for several people to do this at the same time, comparing frequently to see how else it has been done.

The little sketch on the left is to be enlarged to the proportion of 3¼ to 6¾ inches for the drawing on the right. Key points are being plotted—A, B, C, D, etc. The proportional scale, when set, will supply any of these dimensions. With these points determined, it is easy to complete the drawing correctly.

Actually, expressing emotion is as important as the subject matter you choose. The more success you have in communicating emotions through your painting, the more satisfying the experience will become, and the more others will be able to relate to your work. Figures 70 and 71 are examples of applying these ideas to actual paintings.

Power, for an example, is expressed in the sharp and rugged angles of the Rockies, as opposed to the old and worn mountains in other places. The horizontal landscapes and clouds of evening suggest peace and quiet. Even the gradually changing warm colors of evening sometimes add to the quietness. The soft grayness of fog may create a sense of silence, or aloneness and melancholy. Curving strokes of blowing grass may suggest gentleness whereas angled strokes indicate the power of wind, with tumbling clouds to match. This is but a brief suggestion of possibilities. Our world is full of symbols which we may find useful in expressing ourselves. All we have to do is look and think!

Figure 70

Northern Lights at Gills Rock
Watercolor, 21x29 inches

The unnatural light on the frozen harbor and snowy roofs combines with the explosive motion of light in the sky to create excitement and mystery.

Figure 71

Day's End, Gills Rock
Watercolor, 21x29 inches

In contrast to the painting on the left, subdued color and pastel tones of sky and water combine with horizontal motion to create a mood of peace and rest.

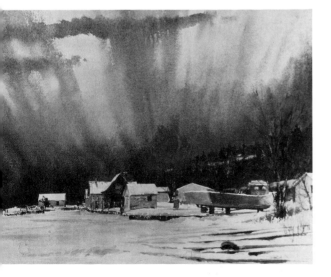

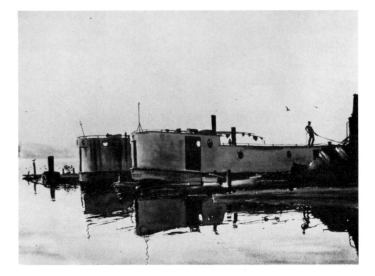

The various factors discussed in the foregoing pages all go into making a good painting. Many of the suggestions are peculiarly adapted to use with watercolor, though I see them as essential for all painting and drawing.

The first and foremost thing about painting in watercolor is to remember that it is a wet medium. Using transparent washes so that the white paper shines through, it interprets light as no other medium can. If you fail to take advantage of this characteristic, there is no point in doing the painting in watercolor. Two things should remain uppermost in mind as you work: transmitting your emotions, and making the most effective use of the paper in doing it.

While you can learn by individual discovery, by reading books, by studying the work of other artists, and by the learning procedure of workshops, the end result must be your own individual style, an expression of your own moods and emotions.

Beginning the Watercolor

There is no universally correct way to begin a painting. Procedure is determined by the physical circumstances, even in the studio. Available time is a very real factor, particularly late in the day. Approaching storms, changing tides, a limited physical space in which to work, even unsympathetic or overinterested bystanders have bearing on this.

Rapid sketches and photographic references plus other notes are the best answer in some cases. This allows for much more complete planning in the studio before the final painting is executed. I am positive, however, that it is important to do as much painting as possible in a new and unfamiliar area before any attempt is made to study color slides, sketches, and notes, with the idea of doing studio paintings.

You may catch the mood of an area by observation, and get a strong emotional reaction to what you see, but in the long run you will have to round out your study through actual painting. You must know what colors are peculiar to that place, what atmospheric conditions exist, what sort of activities go on, what the people are like, what, if any, wildlife exists there, and what the tempo of life is. Then your emotional reaction will be valid.

To say, "I will always start with the darkest areas, or the lightest areas, or the center of interest" is to impose artificial restraints on the painting. Generally, however, I do plan to do the sky late in the painting procedure for a couple of very good reasons. If there is a

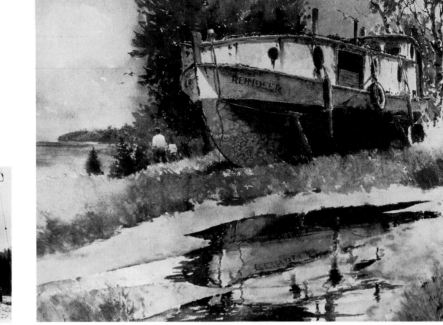

Figure 72

noticeable hue or value in the sky, it is almost impossible to get the warm colors of trees and foliage completely fresh over a pre-painted sky. There is always the danger that the objects thus painted will look somewhat reduced in brilliance, or even "cut out" and placed on the sky. The second reason is that a definite sparkle is obtained by the necessity of painting around objects like trees, since in order to not run sky tones over them, bits of clear white paper will be left untouched (Figure 73). If trees are going to be darkly silhouetted on a light sky, as occurs in winter, or the trees are reduced to limbs and branches devoid of foliage, they can be done over a prepainted sky. However, even then it is well to leave larger trunk areas free of sky wash so that you will have complete freedom to introduce lighter, warmer colors if you wish.

Plan to introduce some areas of dark as soon as possible so that you can establish the span of values from dark to light. Try also to put in all the large, simple washes (other than sky) as soon as possible so that you can evaluate the amounts of greatest light needed without being confused by large areas of white paper. In areas to be left untouched, it is better to leave a little too much white than not enough, since it is easy to reduce these areas in size as you go along, but virtually impossible to reintroduce whites once they have been washed over. State each value positively, as strongly as you feel it needs to be, on the first try. If this is not done, successive correcting will throw other values off, since all values are relative. Moreover, muddy color is likely to result. Indecision in a watercolor is as obvious as a billboard!

Figure 73

October Reflections
Watercolor, 21½ x 29 inches

Note the subject material on the left (Figure 72) from which this painting was created. The sky was painted after the trees—which allows for the little sparkles of white paper left around leaves and trunks of the birches, as well as the maples. Even the distant evergreens have bits of this sparkle, since the water was painted after these trees.

If shadow areas are changing rapidly, either lay them in at once, or indicate them lightly in pencil. Otherwise exciting features or details may be forgotten as the light changes.

When washing in a large foreground area, decide whether it should be a simple wet wash, an area of dry brush, or a combination of both. There are three kinds of edges: hard, soft, and rough or textured. Usually they all occur, in varying amounts, in different parts of a painting. If there is any motion in the foreground do as much as you can to suggest this with the direction of the initial strokes. Also, any texture or change in value suggesting terrain should be dropped in wet at this time, as well as any deeper value toward corners of the painting, if needed.

Many textures can be obtained by using a knife or a brush handle in this damp wash. Your intention should be to say as much as you can, as simply as you can, in an initial wash. The less detail that needs to be added later, the fresher, more direct and spontaneous the watercolor will appear.

The same procedure should be followed wherever possible in painting individual objects such as tree trunks. Values and hues are incorporated in the first wash. While the wash is wet, texture is added, using either a knife or a brush handle if necessary. The side of a building should receive vertical or horizontal strokes depending on which way the boards run, since even the slightest indication of brush strokes may suggest texture and construction (see Figure 74). Any build-up of value toward one end or the other of a surface for contrast should be incorporated in these strokes. Any hint of changing color can be dropped into this wet wash as well.

Figure 74

South Carolina Sawmill
Watercolor, 14x21½ inches

A simple foreground with bits of detail, a roughly constructed mill, and surrounding oaks suggest a way of life. A buildup of darks and lights where they meet gives strength to the composition. Directional strokes give foreground texture. Strokes also follow direction of boards.

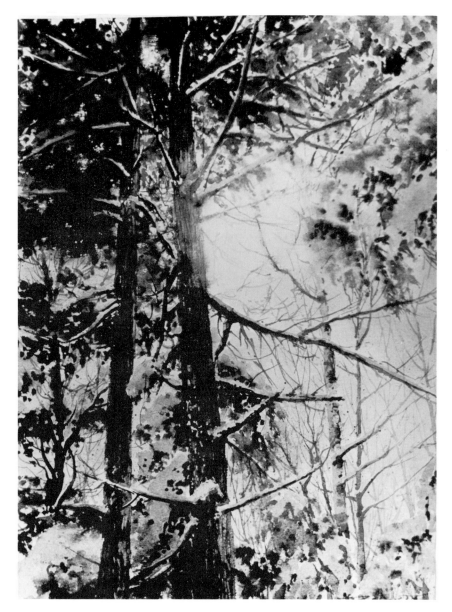

Figure 75

Winter Hemlocks
Watercolor, 15⅝ x 11¾ inches

This painting demonstrates the use of all three types of edges—hard, soft, and rough. It also shows the use of brush-handle texture in the tree trunks. The sunburst is done by wetting that small area and painting into the edges. Liquid mask was used first to hold snowy branches while large washes were added.

As you go back to your palette for additional paint, frequently pick up bits of other colors so that there will be constant excitement and change in the washes you apply. Deep shadows coming from eaves, warm reflected light from the ground, cool light from the sky—all of these variations can go into a wall as you paint it. Again, hints of texture produced with a brush handle are added to the wet wash. Any rocks in the landscape receive similar treatment.

After doing all objects such as buildings or trees which project into the sky area, decide how soft you wish the distant edges to be. If they are to be very indistinct, paint the sky leaving the lower edge moist enough so that you can come back with the distant hills, mountains, or woods, laying this wash in wet against the wet edge of the sky.

If you wish to have a more distinct line at the horizon, let the sky wash first dry completely, or nearly so. In some instances, a dry brush will help to make this edge more descriptive.

As you cover your entire sheet with these initial washes, do not stop to add details. When all is completed, then, *and only then,* consider what additional details are needed. Begin with the center of interest and complete it.

As you move across the painting away from the center of interest, reduce detail so that nothing will take away from that center of interest. It is always a temptation to add too much. Therefore, leave all finishing detail until the last. Invariably if objects are completed as the painting progresses some detail may be carried so far that there is no chance to make the main story stand out.

There are, however, always exceptions to any procedure. You must be an opportunist. This was forcibly brought to my attention a number of years ago when painting in the Seattle area. I gathered my gear and went to Salmon Bay, where the idle fishing boats were moored. On arrival I observed what appeared to be an approaching rain storm. About to turn around and leave, I noticed a couple of ladies on a nearby dock busily painting. Not to be outdone, I hastily got out my paints and began. The sky was full of dark, rolling clouds and the masts and rigging of the boats were dramatically etched against it. The water had a dark, oily look. Wishing to record the sky, if nothing else, I hastily sketched in the forest of masts and rigging and plunged into painting the stormy sky, working carefully around all the uprights. Still no rain—so I rapidly penciled boat hulls and recorded the dark water.

Three or four hours later the sky was clear blue! Even though it was difficult to remember all of the earlier values, a successful painting resulted. It was loaded with the turmoil and the emotion caused by the approaching storm, but had I not captured the mood early in the painting, while the sky was so threatening, it would have been quite an ordinary picture.

At other times people or animals enter and leave the scene and it is necessary to hastily capture them complete with detail while there is opportunity.

On a March day when there was a light cover of snow, I was sitting high above the Mississippi River in the little river town of Chester, Illinois, to do a painting of "Mississippi River Country." Thinking about the theme, it occurred to me that what the river really needed to complete the story was a tug pushing a string of barges. Imagination, no! The throb of approaching engines brought into sight a tug and barges! Out came my Polaroid camera. As the tug reached a likely spot in the landscape, I took a black-and-white shot of it, and also made a hasty sketch. Studying my sketch and the photo for the proper wake and boiling muddy water, I painted the river freight moving below in the yellow flood of the spring runoff. A plus mark for painting on location (see Figure 76)!

"In Out of the Fog" (Figure 77) was prompted by the soft mystery of fog-enveloped fishing boats and sheds along the Lake Michigan shore. Introduction of fishermen unloading the day's catch added interest and a whole new dimension, suggesting the hazard of weather in a fisherman's daily work, the courage of the men who carry out their daily tasks regardless of weather. The implication is that the danger is past, with the boats safely in port. The painting is intended to suggest respect for these fishermen, and it will re-create their experiences for them as well. It communicates an awareness of and a reaction to the life around me—a most valid reason for doing the painting.

Here is a description of the procedure of this painting. After the preliminary drawing was completed, liquid mask was applied to the light side of the birches, the radio whips, radar drum, light sur-

When this masking was completely dry, the full sheet was immersed in the tub for about five minutes until well soaked. Then it was stretched out on a sheet of wet metal (tempered masonite, glass, or Formica can also be used), to prevent rapid drying.

the background, the distant fish shed, and the purple-gray wash for the shape of the birch tops. The white vertical edges of the boats were blotted dry to keep the sky wash from flooding in on these surfaces. The deep red-purple fish shed on the left was also painted in with a "charged wash," (i.e., loaded with pigment) while the paper was moist enough to let it blur somewhat. Again the areas for the birch trunks were blotted, also to keep color from flooding them. The foreground was painted with some orange dropped into the wash at the base of the birches to bring this area forward.

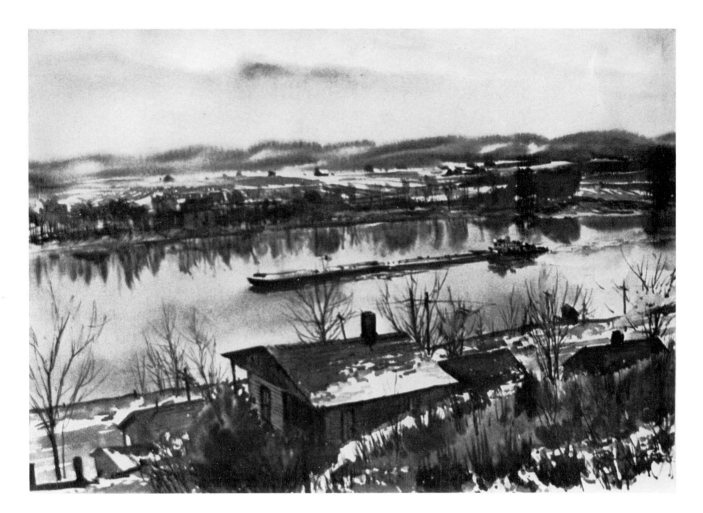

Figure 76

Mississippi River Country
Watercolor, 21x29 inches
Collection of Changing Times Magazine

This painting contains a good mix of hard, soft and rough edges.

The drying rack for nets to the left of the birches was lifted out of the wash with a fairly dry brush and later finished when the paper was considerably dryer.

Now the painting was removed from the sheet of wet metal, the edges were dried with a blotter, and it was taped down on plywood with paper packaging tape so that it could dry faster and tighten into a stretch. The values on the boats were applied while the paper was still somewhat damp. Limbs and trunk detail were added to the birches. Some splattering of color with a loaded brush was applied to the foreground. Darker shapes were added to rocks in the immediate foreground when the paper was nearly dry.

The figures and the details on the boats were then painted in. Finally, when the paper was completely dry, the last little crisp details were added. The masking was removed and edges on the birch trees and boats were softened.

I always draw first, then use liquid mask where white areas will be small and difficult to hold, thereby enabling me to then soak the sheet thoroughly. I can then spend considerable time working "wet-on-wet" with all the large areas of a full sheet painting. Then

Figure 77

In Out of the Fog
Watercolor, 21x28½ inches

Fog added considerable glamour to this little spot on Sand Bay and prompted using figures and developing a story.

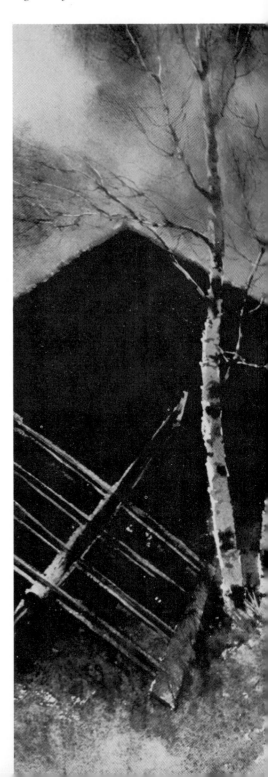

by making a conventional stretch on a board, there is plenty of time to do areas which need to spread only slightly, before finally doing areas that need to hold detail. Figure 78, "Spring Voyageurs," and Figure 79, "Renfro Valley Morning," were also completed in this fashion.

Frequently the use of blotters and the lifting technique eliminates the need for any masking of areas. I like the opportunity of working wet-on-wet and being able to combine it with later distinct wash and detail passages. Sometimes a limited area can be wet in preparation for wet-on-wet painting, but I find that a thoroughly soaked sheet will hold color where it is applied better than surface wetting, which allows more spreading of color.

In composing a landscape it is not always necessary to be limited by the exact appearance and arrangement of the subject you've chosen to paint. Some artists like to take photographs or make sketches on location and complete the picture in the studio. An advantage of working this way is that you are free to rearrange the various elements of your subject as you compose the picture in the studio.

When I am working this way from photos or studies made on location I first find a promising subject and then carefully study the area around it for elements that I can use—interesting trees, rocks, buildings—then I put it all together in the studio. I make my sketches and take my photographs from different angles and

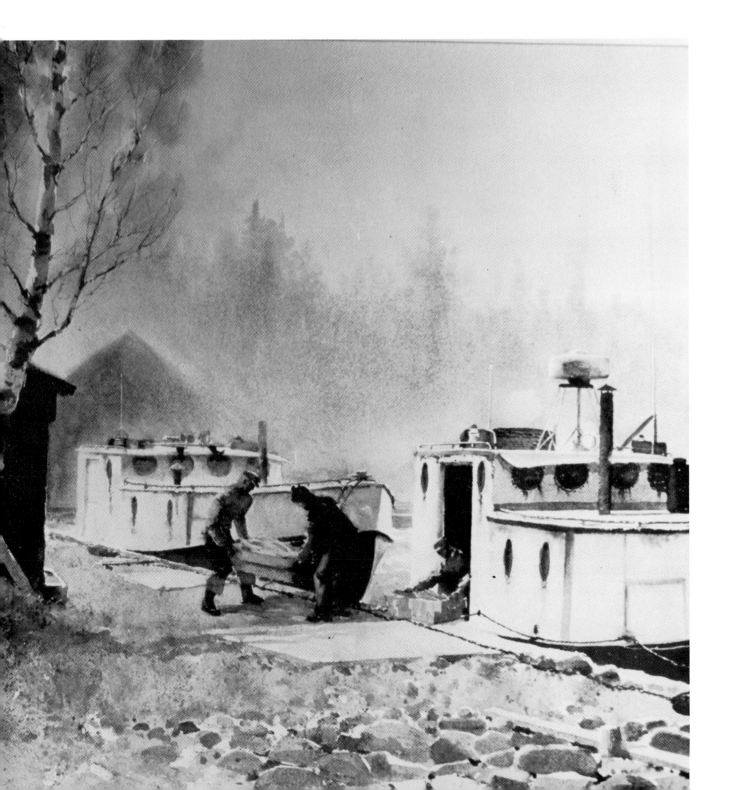

Figure 78

Spring Voyageurs
Watercolor, 21x29 inches
Collection of Mr. and Mrs. Elick Lindon

For eight years I had in mind doing a painting of geese flying over tree tops. No amount of sketching produced a good pattern. Shortly after moving to Door County we heard geese and rushed out to gaze upward as they winged their way over the birches. I realized sprawling birch limbs were the answer and immediately began this painting.

Figure 79

Renfro Valley Morning
Watercolor, 21x28½ inches

The morning mist tied all the field patterns together in a subtle checkerboard of muted color. This painting was done wet-on-wet on a soaking sheet of 300 lb. D'Arches rough. Color and value were worked carefully into the initial washes. Final details were added to the completely dry sheet.

Figures 80 and 81

The Quiet Time
Watercolor, 14x21¹/₂ inches

In this case a simple reshuffling of the cedar trees in Figure 80, together with the introduction of a clump of birches from far off to the left, kept the mood of the day, but made better use of it (Figure 81).

points of view so that I will have a record of actual objects native to the area. Thus I maintain the feel and mood of the location when it comes to painting in the studio, even though I might change the direction of light, or the color scheme, or introduce figures and activities consistent with the scene but concocted from my imagination.

Whether you're working in the field or the studio you don't have to slavishly document exactly what is in front of your eyes. You are free to use your imagination and your good judgment to invent and compose. What matters in the end is a painting that stands by itself as a successful achievement.

Figure 82

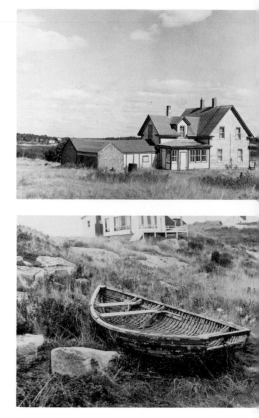

Figure 83

Photograph of an interesting structure near Digby, Nova Scotia, and below it a battered old boat at Peggy's Cove (Figure 83). Both were used to create the painting on the right.

When Changes Are Called For

Since watercolor is transparent, it is a revealing medium. Changes are very difficult to make. For this reason, it is usually better to re-do a painting than to try to make extensive changes on the original. Because it is almost impossible to make an exact copy of a watercolor there will usually be something new, fresh, and unique every time a painting is done again.

The painting "Twilight Visitors" (Figure 85) was based on photographs which showed two groups of farm buildings across the road from each other. A small watercolor of this scene made a good composition, so additional thumbnail sketches were made. The full sheet which resulted had an unfortunate area of bad wash in the right hand area of the sky. Since 300 lb. D'Arches was used, it seemed possible to work it out. Everything failed; it got worse. I finally decided to start over even though many things in the original were unlikely to be captured again. However, I redrew the subject on a fresh sheet and began again and in the excitement of painting forgot the original and forged along on the new one. When it was finished, it surpassed the first one in almost every respect—even the deer looked better!

I am completely convinced that if you have a good subject and have not done it justice, even though you have a salable painting, you should do it over until you have the best painting possible. Better to throw the first try into the drawer and do a second one than to be represented by a work with which you are dissatisfied. The back side of rejects can always be used for a new painting, or at least, to practice on.

There are times, however, when a painting can be corrected. In the painting "In Out of the Fog" (Figure 77) discussed a few pages back, I was dissatisfied with two of the figures. The painting was

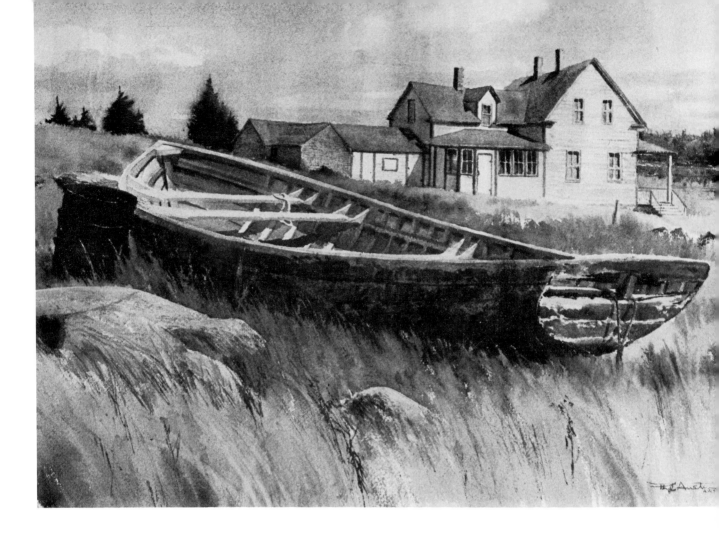

Figure 84
In a Nova Scotia Field
Watercolor, 20½ x 28 inches

The movement of this composition begins with a light in the lower right foreground, traveling to light rocks, rusty dark drum, curving bow of boat, evergreens on the horizon, faint clouds, chimneys of house, sunny end of building, darker middle ground, and back into end of boat. In the process, the boat with its chipped paint, shadowed ribs, and sunlit seat boards captures the center of interest.

reasonably successful as a whole so I convinced myself that the figures would do.

The next day they looked worse. Starting with a brush and cleansing tissue, the figures and the whole bow of the second boat were gradually washed out, the sheet dried and reworked. This time the figures worked well with no evidence of change. To do this requires a good, heavyweight, hard-surfaced paper which allows for such treatment.

Sometimes it becomes necessary to add to a painting that you had thought was finished. A painting of an old boat sling was done on location on a cold, nasty, foggy day. Enamored with it, I submitted it for a national show, which it failed to make. When it came back, careful study revealed it had potential for a much better story. I started over and added a fisherman in rain gear walking in with oars over his shoulder, but the second painting failed to have anywhere near the feeling of fog present in the painting done on location. With considerable trepidation I decided to work on the original, knowing full well that it might be destroyed. The figure was sketched in several sizes on tracing paper and experimentally placed in various locations until the best spot was found compositionally and storywise. Then I traced him into the original painting and began to carefully wash out any color which might be strong enough to show through the figure. This completed and the paper

dried somewhat, the figure was painted in. The painting now contained a much better story. It is unwise to become so enchanted with your work that you fail to admit you can do better.

Searching for Material

When you are "prowling" a new area in the car and see a likely spot, try to find a suitable pullout where you can park and study things more fully. As you move on, look in the rear view mirror. You may discover a whole new perspective behind you.

Sometimes it also pays to turn around and go back for a second look. How many times when something along the road seemed to have great possibilities, have you driven on, promising that undoubtedly there would be something as good or better ahead, or that you could always return? Many times I've regretted such a decision. Once, however, while driving through southern Indiana, I passed a marvelous, old-fashioned, horse-operated sorghum press; I drove on a couple of miles, but finally decided to go back. There was an excellent place to park and several hours were spent doing a most unusual and interesting painting. We did not see another press the remainder of our trip. When you see a good subject and can stop safely, do so! Two more examples:

I was driving down a New Hampshire backroad on a sunny October day and was inspired to do the old stone wall in Figure 86. With colorful maples lined up and an accumulation of smaller

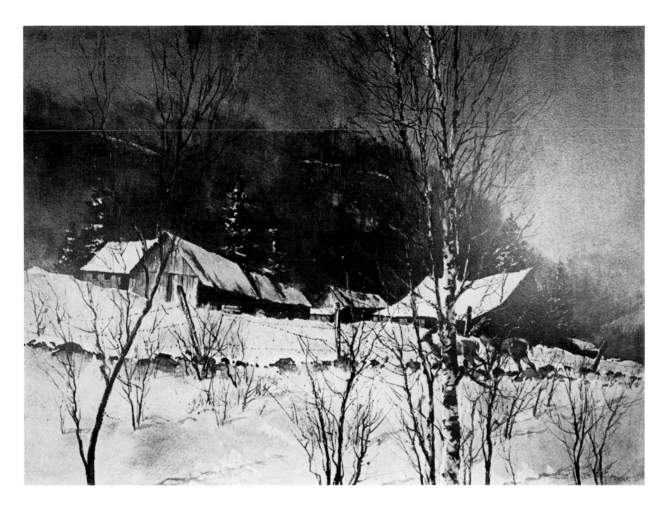

Figure 85
Twilight Visitors

Watercolor, 20x29 inches
Collection of Mr. and Mrs. Sven Jorgensen

*In this final painting a snow covered
wall had been added, birch trees cut-
ting the foreground. The background
woods were raised, glimpses of snow
were added to create a hill, and final-
ly, deer to complete the story of a
winter dusk.*

rocks together with some large ones, it was a story indeed. What sweat it must have taken to clear the fields of such a clutter! How could the early farmer ever have moved some of these blocks of granite? The painting finished, I packed up to leave, turned the car around and drove less than a hundred yards and there, unnoticed earlier, was an ancient family graveyard, so common to New England. Several enjoyable hours were spent doing the painting "Family Graveyard" (Figure 87).

Figure 86
Old New England Wall
Watercolor, 11¾ x 15⅝ inches

The loosely penciled wall was washed in with a light gray, leaving edges and bits of white showing. Variation of value as well as color were added into the wet wash. Eventually the stronger areas were painted in with more definition in the foreground. Rugged maple trunks were washed in and brush-handled for character. Loose foliage and foreground rendering followed; the sky was painted in last, around trunks, limbs, and leaves.

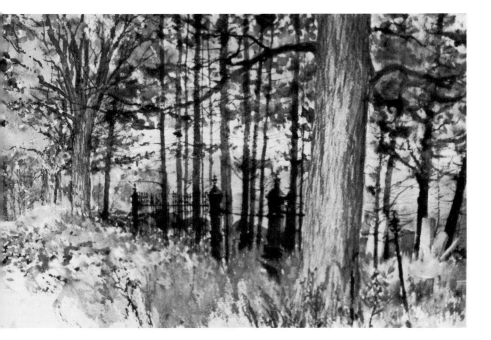

Figure 87
Family Grave Yard
Watercolor, 13¾ x 21¾ inches

This subject was just off the road on a slight rise. The setting was a beautiful and quiet story of the end of labor, showing respect for the past, tribute to our ancestors, and a reminder of at what cost we have land today.

Experimenting Safely

There is a safe way to test additions to a painting while you're working on location. It sometimes becomes obvious that an object such as a fence post needs to be added for the sake of story or composition. Rather than paint them in wrong in the first place, take a brush handle, a pencil, or a twig, and drop a shadow on the painting where you are planning the addition. It is then easy to see whether the idea is valid and if so, the exact size and spot where the post should be placed (see Figure 88). Similarly, if you are considering adding a tree or some brush, select a weed which will give a suitable shadow and use it to experiment. This answers questions without causing regrets (see Figure 89)!

It sometimes happens that the foreground may need a dense shadow from an object outside of the picture plane to improve composition or direct attention into the painting. A piece of paper torn to cast the correct shadow can be used in a similar way to test the result before applying paint.

When Opportunity Knocks

Sometimes accidental effects give a clue to improving a painting. Once when I was in the car painting some fields and a nearby grove of trees on a cold winter day, such a lucky happenstance occurred for me. The finished painting was not very exciting. I rolled down the window part way to get a little fresh air. The painting was lying on my lap in such a way that the light coming through the glass made a slightly darker value where it fell on the paper. It suggested a distant mountain seen through the foreground trees. The illusion improved the painting so much that I misted the area with my spray bottle to soften the color, and then I swept across the area with a big brush loaded with an appropriate wash. This made it into a good painting!

On a sunny day I was completing a painting with a simple foreground of a field with a roadway running back to a group of farm buildings. Broken clouds began moving in and a shadow suddenly fell across the foreground field, leaving the buildings in a patch of sunlight. The effect was so much better than my painting that I hastily misted the paper, mixed an appropriate shadow wash, and dashed it across the foreground field. Result: a greatly improved painting. Such chance circumstances can sometimes teach us new ways of thinking when we paint.

In the studio fortunate changes of sunlight aren't likely to happen, but it is possible to make paper shapes to use for shadow experimentation as described on page 91. Cast shadows are a fast, safe way to test an idea.

Many artists do all their paintings within a small geographical radius, feeling this is the best way to work. Others travel to distant areas to paint. If travel is your inclination, it can enrich your life and your work. This is a very personal choice which depends on individual preference. If, with growing expertise, you choose to go farther afield for subject material, there are some things to keep in

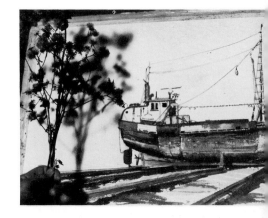

Figures 88 and 89
Experimenting with proposed objects in a painting of a "dragger" along the St. Lawrence River.

mind as you plan. Plan to stay in an area long enough to get the "feel" of the place so that your paintings will reflect a genuine understanding. Try to avoid the obvious things that everyone sees (and photographs). Get off the beaten track so that you see life as it is, not the fake facade sometimes presented to the public. Find the unusual views and activities that make the area unique. When you see photographs or hear stories of unusual or relatively unknown areas or scenic wonders, begin to plan your visit before everybody else gets there. You will find your painting trips far more satisfying and rewarding.

From the beginning my wanderlust has prompted these kinds of painting adventures. My painting career has proved a magic carpet, allowing me to search out many new and stimulating places to paint, supplying me with a wealth of material and knowledge which brings me home to examine more familiar surroundings with a fresh eye and to paint with new enthusiasm.

Problem-Solving Demonstrations

Trees

Trees have been celebrated by poets, writers, and artists since earliest history. They are worth special study. Early in my painting career, baffled in my efforts to paint trees, I concentrated on doing nothing else through all four seasons. Trees came to be individuals much like people, reflecting the life they had experienced. I now look for trees with characteristics all their own and seek the best way to interpret them. Here are some ways I find effective.

When painting foliage, look for the pattern of light and dark values. Then begin with the areas of most light, painting those areas only. Leave a dry surface on which to add the middle and dark values. In this manner you can hold any shape or definition wanted, and you can touch one wash to another for blending.

Figure 90
This spreading tree is a good one to start with. Its spreading top catches a lot of light, which is put in very wet on the dry surface.

Figure 91
Now the second value has been put in, again very wet, so that it has blended readily in several places. Again, the paper is still left dry for the third value.

Figure 92

The third value (in the case of a green tree made with a mixture of ultramarine and vermilion with viridian added) is painted on the dry surface and, like the second value, is blended in with spots of earlier washes.

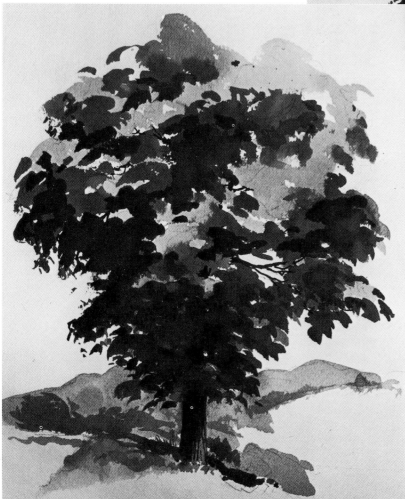

Figure 93

The trunk has been added and textured with a brush handle. The branches have been tucked into openings left for them and some of the surroundings have been added. It is well if this can be done while the tree is still somewhat damp.

Group of Trees

If you are doing a group of trees, follow the same procedure, by painting *all* light areas first as a pattern, then middle and darker areas, as shown here. In doing this, even though you work on a dry surface, use a loaded brush so as to have wet areas of color and ample time to create flowing passages before the wash dries.

In painting trees (unless you wish to go into great detail) use simple areas of wash and considerable blending of values and then

Figures 94 and 95
This is a group of oak trees on a California hilltop. The overall shape of the tree tops was sketched, together with a careful drawing to suggest the character of the tree trunks.

put in a few detailed leaves on the fringes of the trees and perhaps a few random ones at the edges of light areas. These leaves will be sufficient to identify the entire tree. Also study carefully the shape and limb pattern of each variety of tree so that it can be suggested by brush strokes—telling as much as you possibly can in the initial work. Studying and painting bare trees in fall and winter will help in this.

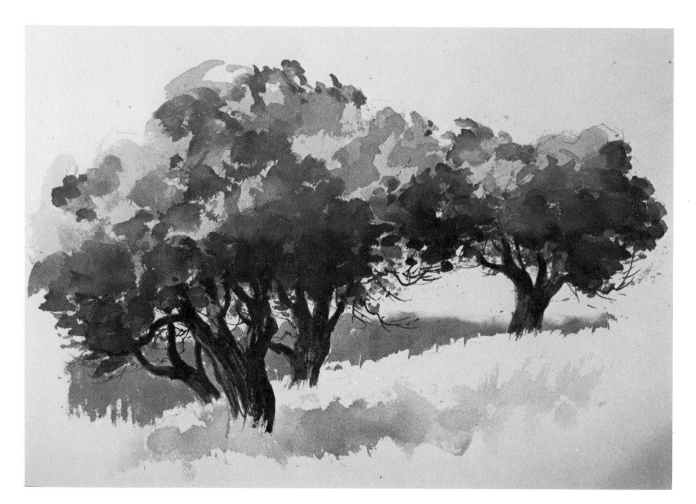

Birches

When painting birch trees, pencil the large shapes lightly and then paint foliage and the shadow side of the trunks and branches. This trunk shadow can be a gray wash blued somewhat with a little cerulean, but as you go higher into the tree and also onto limb extremities, add a little cadmium orange and a bit of vermilion to create a warmer shadow on the trunks and even a rusty color on branch ends and smaller twigs. This is characteristic of birches. In the late winter and early spring these limbs and twigs become almost alizarin in color from the forming buds. A birch tree shape

Figure 96
In this final step the third value of foliage is added, pulling the tree shapes all together. The trunks receive texture in the initial wash, plus further detail when dry. Branches and twigs give character to the trees.

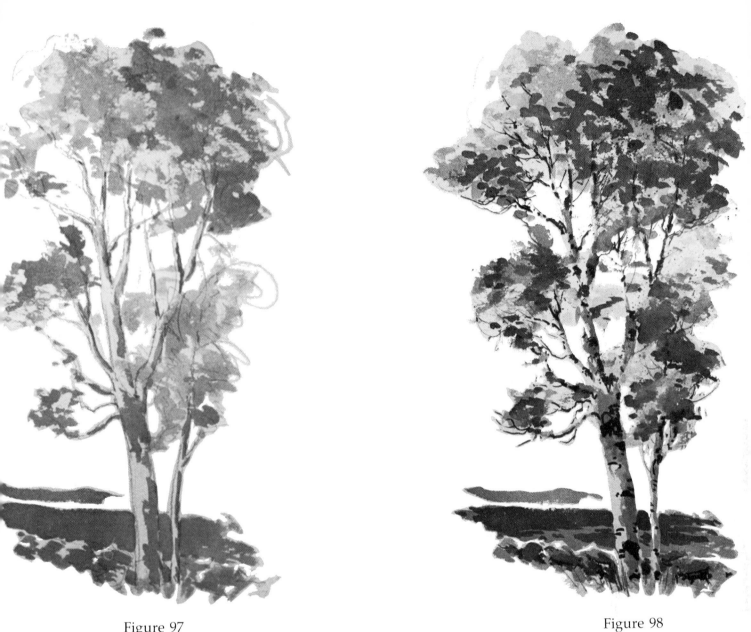

Figure 97

Figure 98

against the sky will require a light gray wash dominated with alizarin.

After adding the second value to the foliage, add the darks to the birch trunk and limbs. Keep these darks scattered with no regular repeat of size or position. Frequently the darks will appear as a saddle in a crotch where a limb or a side branch begins. These darks remain where a limb has once been as well. In planning the surroundings for a birch, employ darker areas or different hues in some places to define the white edge of a light trunk or limb. In other places deliberately allow lights to create a lost edge—similarly with darks against the shadow side of the trunk. This gives a freedom and looseness which causes the tree to be part of the landscape.

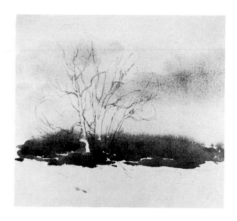

Figure 99

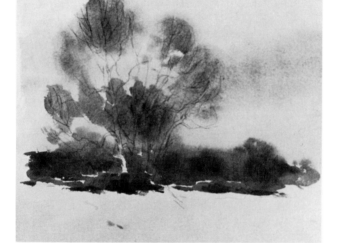

Figure 100

Willows

Figure 101 is a little watercolor sketch of a winter swamp with a cluster of old, battered willow trees. In the first step the sky, distant woods, and brush clumps were washed in. While this was still damp some darker wash was dropped into the sky where the shape of tree limbs, branches, and twigs was to be. A little more was added for a tree clump or two in the distance. While these additions were still damp some brush handle work gave limb texture to the wash. In the next step tree trunks and branches were painted in, feathering out into this wash. Finally a few foreground accents and weed stalks suggested atmosphere. This is a very good way to create winter trees.

A second method is to paint in the trees and then soften the limb ends while they are damp and if necessary, add a little wash for the tree form. This allows a little more control but sometimes does not have quite the freshness of the method here demonstrated.

Trunks

The next demonstration shows the creation of bark texture with wash and brush handle work. Note the trace of brush handle work in the initial wash. A second darker wash also carries similar texture. (Remember, when applied to a wet wash, a darker line is

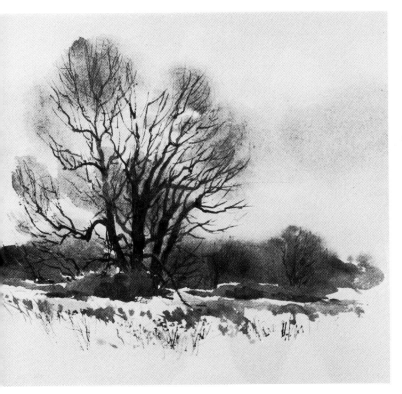

Figure 101

Figure 102

achieved, but when applied as the wash begins to dry, lighter marks appear.) A few darker brush strokes applied while the paper is still slightly damp finish the texture of this maple trunk.

Cedar Trees

In painting cedar begin with the light side of the trees, using a warm wash of cadmium orange and viridian. Next mix a darker value, using more viridian and some ultramarine with the orange, and apply it while the first wash is still damp so that considerable blending occurs. Following this, mix a dark value with vermilion and ultramarine, adding veridian until the dark becomes a proper green. This, too, is added while the second wash is still somewhat damp. This time keep this darkest dark in the center of the trees, so that even when it blends with the lighter wash there is a cylindrical feeling to the tree forms. Lastly, if more softness is needed, use the spray bottle for a burst of fine mist over the trees, allowing the outer edges to blur slightly. (It might be well to practice this on a few sample trees before you try it on a painting—lest you wash away a good area.)

Figure 103

Figure 104

Figure 105

Figure 106

Pine Trees

Pine trees have much individual character. It is always a question
as to what is the best approach. The pine on the right was done
with an effort to keep control, so the limb areas were moistened
with clear water. After the glisten was gone, I washed in the light
areas, then mixed a darker value and added it while the first wash
was still damp, allowing considerable blending. Then, when dry,
came the details with a small brush.

The two trees on the left were painted rapidly, again following
the procedure of light color first, then darker values. Immediately
after laying in these washes, I sprayed the trees with a dash of mist
so that edges blurred considerably. (If working in the studio, a
1200-watt high speed dryer can be used to arrest the spreading if it

Figure 107

seems to be going out of control.) After this was dry, I did trunk, limb, and branch detail with a small brush. This second method is a good one. It takes practice, however, to avoid getting too much moisture on the trees, thereby losing character.

Evergreens in Winter

When you paint winter evergreens with snow on them, put liquid mask on the snow areas first so that you can paint the tree freely and still hold the snow areas. The first step shows this with masking on the limbs (also some on ground area and white areas on the little building). The sky was painted, staying clear of most of the tree area.

Figure 108

Figure 109 Figure 110

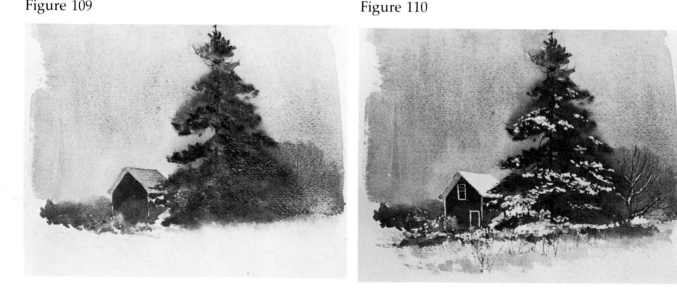

The second step shows the evergreen painted in and misted with spray to soften it. In the third step the liquid mask has been removed and an important addition made. I almost never leave a masked-out area as it appears when the mask is removed. In this case, a second value was added for shadows and the weed stalks across the white areas left in the foreground. Unless this is done, the white masked areas will look artificial—like cutouts.

Foregrounds

In the first step I used a full brush of thin wash on D'Arches rough paper. A diagonal stroke, using the full side of the brush with a light touch, allowed some paper to show through, to increase texture. While this was moist some horizontal strokes of darker wash were laid in and a brush handle used to increase texture, following the direction of the earlier brush strokes. Finally, after this was dry, I added a few blades of grass and weeds in places. (This should be

Figure 111

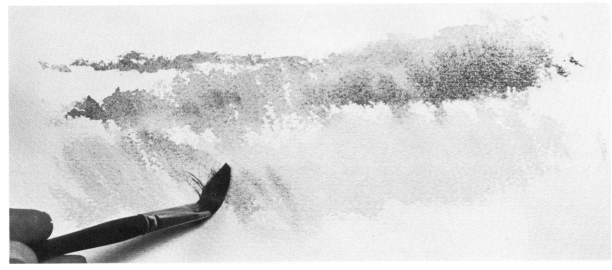

Figure 112

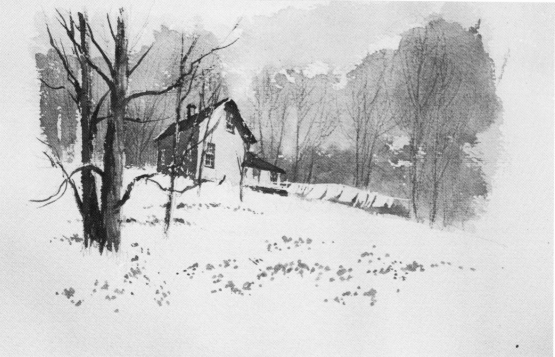

Figure 113

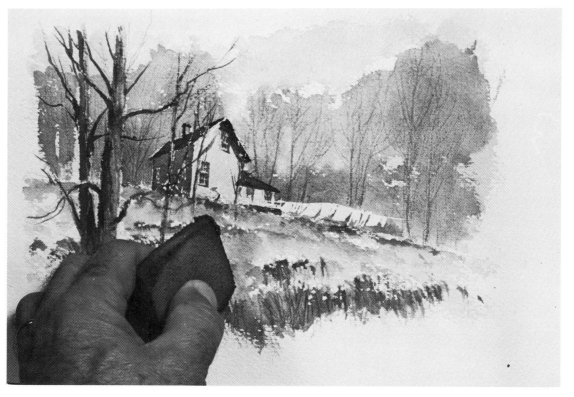

Figure 114

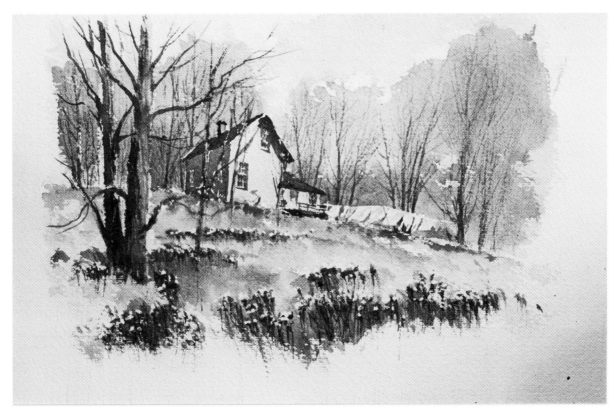

Figure 115

done very sparingly, since a few strokes will "read" for the whole area.)

In Figure 113 is a landscape with a foreground consisting of a simple flow of wash with darker values to indicate uneven ground. The spots in the foreground were bits of liquid mask, which were removed (Figure 114) after the foreground wash was applied, to allow for fluffy heads of weeds which make up a slightly more detailed foreground. All the trees in the background wash at this point were merely scratched with a brush handle into the damp wash. In the next step the foreground wash was completed and dark weed stalks added before removing the mask. Final details were completed, giving the foreground the main emphasis.

Rock Walls

This first rock demonstration is a wall of field stones piled up with little effort to fit stones together. I first made a careful drawing, then washed a shadow area on the entire wall as one piece, varying color and value slightly in some areas. The texture was achieved by sprinkling some salt on this wet wash. In the next step I mixed a darker wash and again went the whole length of the wall, molding each stone a bit more.

At this point the foreground was worked into the bottom of the

Figure 116

Figure 117

Figure 118

wall, which was still damp so that color would flow slightly, losing some of the edges. Some old mullein stalks helped to break up the wall so that its compositional pull toward the distance would be slowed. Dark trees were added beyond the wall to etch the top of it with light. The salt was still working on the washes of the wall. This is something that can't be hurried. Drying the wash with a dryer would stop any further texturing of the wash by the salt. Value relationships could now be compared. A third value was applied to the wall. Final touches included putting in seams and dimples in the limestone and adding a few dark pockets of shadow on the nearer part of the wall. The final result then carried well, as the greatest amount of light and dark were concentrated where the most detail was—the center of interest.

Figure 119

Stone as Masonry

These dilapidated stone steps are part of an old stagecoach stop at Hilt, California. They make an interesting subject to demonstrate painting of rocks used in masonry. I began with a careful pencil drawing, making sure the perspective was accurate. The old burdocks were included to explain the crumbling steps.

A light wash was laid over all of the stone areas, leaving white paper for mortar joints, as well as light-flooded surfaces such as the steps. Cadmium orange with a bit of ultramarine and vermilion added gave the color of the old limestone. The weed growth and scattered grass were indicated with a mixture of cerulean and cadmium orange, producing a warm green with some bluish traces from the cerulean (see Figure 119).

In Figure 120 the value of the wash used for the limestone was deepened and used in slightly varying values as the different areas

Figure 120

Figure 121

of stone were washed over. This is easily done if, each time you go back to your palette, you pick up a little of a different color or a variation of value to give individual character to the stones. This procedure brings out the mortar joints a little more strongly. The front edges of the stone steps were deepened to emphasize the lighter surfaces of the treads.

A dark mix of ultramarine and vermilion was added for cracks and shadows from overhanging surfaces, cast shadows from weed leaves, and holes where stones were missing. This delineates the surfaces. A few darker accents molded the rock surfaces further, while still maintaining the overall look of the stonework. The vignette shape concentrated the interest. A final shape of dark etched the top weed leaves and caused the steps to stand out better by contrast, making the remaining whites sparkle.

Reflections

This little sketch demonstrates how to create reflections. In step one the surroundings of the pond, a grassy field, an evergreen, some birches, a cottage, and a shed were painted. Note, that the grass at the far side of the pond is darker than the grass in front of it. This could have been reversed, the idea being to have a light area of water against a darker background and dark water against a lighter area of surroundings.

Now the reflections were painted into the little pond. Objects close to the far edge reflect completely—like the evergreen and the fence posts—while only the higher parts of objects farther away show. Anything low or distant will not be reflected.

Reflections duplicate any action—but in reverse, like a mirror. Thus, a fence post that is upright reflects a straight line, whereas a post leaning to the left will also mirror a post leaning to the left. A few horizontals stroked in will flatten the surface and give perspective. If there is any breeze, images will be fractured rather than sharp. A stroke or two with the brush handle while the wash is drying will add a light ripple which will increase the illusion of a flat, wet surface.

Figure 122

Figure 123

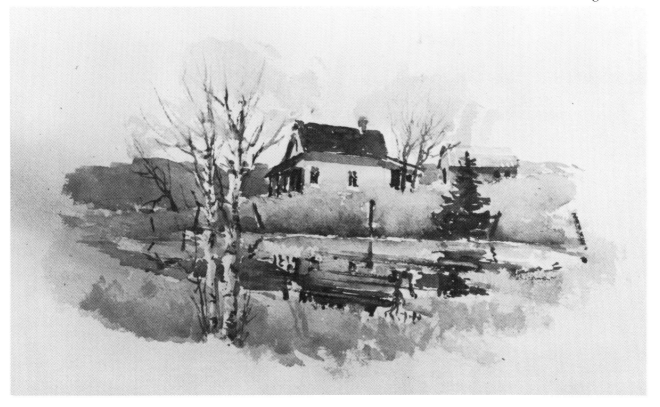

Incoming Waves
(pages 114-115)

Determine the kind of day you wish to portray and paint the sky first, because this will control the color value of the water. In this case the waves are large, denoting wind, so leave some scraps of white as you paint the distant water. As you bring this wash nearer the foreground, wet an irregular edge for the top of the first large wave, and bring the wash to it, leaving a blurred edge of spray.

For the second step, moisten the bottom of the large wave and paint to it as you indicate a deep shadow under the curl. In doing this, leave a few areas of the wave edge dry, but let others blur so that there is a combination of soft and hard edges. The wash in front of the wave is characteristically lighter in value and more green in hue.

In the third step, repeat the procedure for the second wave and the scrap of foam in the lower right. Use long curving strokes, convex in some areas, concave in others, to indicate the swell. If you plan to bring the water all the way to the shore in the foreground, add a little orange to your wash for warmth to indicate color from the bottom shining up through the shallow water. The turmoil of water in front of the last wave can be shown by long, flat, oval

Figure 124

strokes that change color slightly here and there and leave quite a bit of white paper showing.

Finally, use a flat brush with a light wash of pure viridian and follow the curve of the breaking waves to indicate light coming through. Soften some of these strokes in places with pure water to blur them slightly.

In painting a body of water, the sky, as mentioned earlier, is important since a clear sky or one with scattered clouds, as appears here, will produce a deep blue color to the water. Ultramarine with some viridian added will do this. The deep value beneath the curling wave includes viridian, plus some vermilion to create the dark colors. If the sky is overcast, ultramarine with cerulean and vermilion will give a blue-gray water to match it.

Figure 125

Figure 126

Breaking Waves

When painting waves breaking on a reef, rocks, or a dock, you can give them scale by showing spray breaking up across the horizon.

In this demonstration, the sky was painted first with a pale wash against a wet edge for the top of the spray. When this was dry, the distant sea and horizon were put in, again working to a wet edge for the flying spray. This turmoil of the wave was painted with plenty of color in the brush so the wave would stay wet. As the strokes were applied, the color was varied, more green in one stroke, a little more blue in another, to create surfaces that catch light differently. When this was finished, a slight misting with a spray bottle was applied to soften the effect. A few strokes of a light gray-green wash in the foreground gave action in the water and reduced the white areas so the crest could dominate as the largest pure white. The rock surfaces were painted much as in the

Figure 127

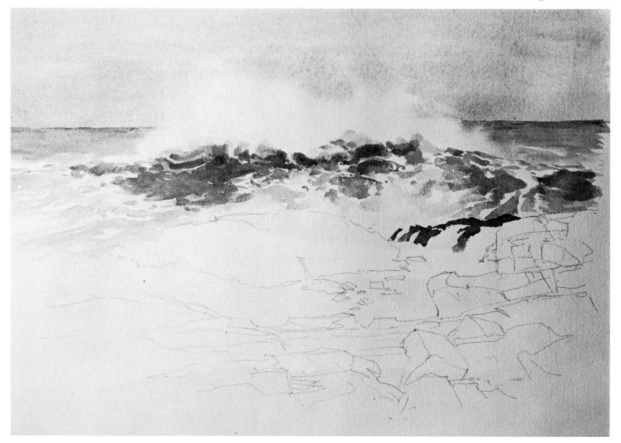

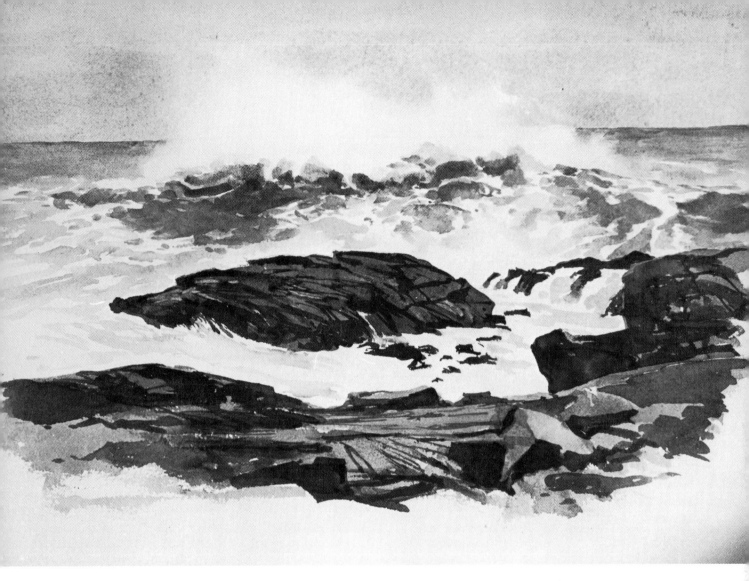

Figure 128

demonstration for rocks shown earlier—light areas first, then darker areas, but working on the entire surface, not piecemeal. Finally, an extreme dark was mixed with ultramarine and vermilion and details were added to the rock surfaces. (See page 144 for color reproduction.)

Rapids and Waterfalls

This is a subject which should be done on location if possible. If you work from slides or photographs the temptation is to paint every little detail "frozen" by the camera. Painting on location presents the challenge of doing a composite of the characteristic action, creating life. It is well to study waterfalls, rapids, waves, or spray for some time before commencing to paint. Then almost from memory, paint rapidly with the minimum number of strokes possible.

These three steps show the process: first, the subject was sketched lightly and all the light areas of the rocks painted with a very wet wash of varying color and value. Salt was sprinkled into this wet wash to create texture on the rock surfaces.

Figure 129

Second, middle values were put in, then dark values, which were allowed to blend slightly. Salt was again added to the wet wash.

In step three, because the darks were all indicated, the values for water were easy to gauge. Edges of the white spray were dampened, directional strokes of blue-gray (very light) curved to follow the flow of the water, blending out into the damp edges of spray. These were slightly deepened in value where they approach pure white areas of foam at the bottom of falling water, not on the flowing slope. A color reproduction is on page 144.

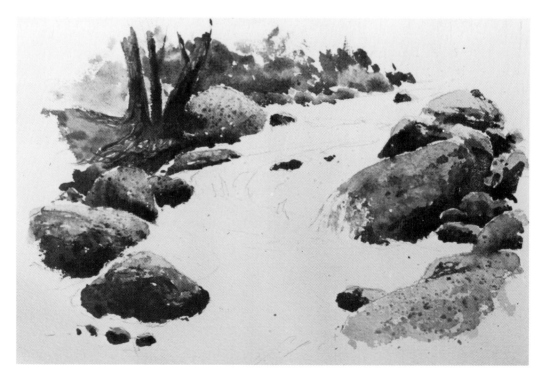

Figure 130

118

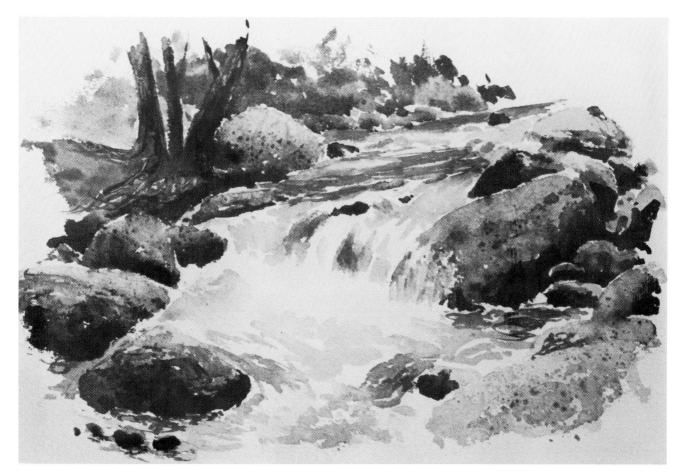

Figure 131

Skies

Skies are exciting to do in watercolor. One of the first things to learn is that a sky must be done rapidly with no second guessing. Once you have committed yourself, do not go back into it and try to change areas (unless you are working "wet-on-wet" and intend to mold some passages). I find the best way to learn to paint skies is to save "failures" and use the backsides of them to do quick sky studies—not with the intent of doing a painting, but merely to find how to achieve the feeling of what is going on in the sky.

Frequently the sky has beautiful, fluffy masses of cloud accentuated by an infinity of intensely blue background. To capture this, choose an exciting area and begin with a brushload of clear water. (You'll have to work fast because it will all change in three or four minutes.) Working on a dry sheet, generously wet the edges and shadow areas of the clouds. Load a large brush with ultramarine to which a small amount of cerulean has been added and dash in the largest areas of blue, working up to the moist cloud edges so that a soft edge results. Occasionally stay in dry areas so you can obtain small bits of hard, ragged edges as well. Then spot in a few blue "holes" in the cloud mass, keeping the edges soft (see Figure 132).

Now mix a slightly warm gray, using ultramarine and vermilion with just a touch of cadmium orange. Put in the deepest shadow areas of the clouds, starting at the lower soft, wet edges where the

Figure 132

120

Figure 133

blue sky begins so that this will blend readily. It is important to match the moist areas with a similar degree of moisture in your brush as you do this. Too moist a shadow wash will fan out into the blue, while too dry a brush will pick up blue, which will result in a hard edge or spottiness as it dries. As you work up into the cloud areas, dilute your gray with more water and occasionally brush into the dry area with a light touch to obtain some dry brush edges of very pale shadow value. Important: now leave it alone and settle for what you have (see Figure 133). This sky appears in color on page 144.

This procedure can also be reversed by painting the clouds first, then adding the blue sky last. The difficulty here is that it is easy to spend too long on the clouds so that the edges may start to dry before you can apply the blue.

These demonstrations were difficult to photograph as they were being done, since they were so moist. Note the glint of wet wash in the upper right blue sky in Figure 132, in Figure 134, and upper right Figure 136.

Morning and Evening Skies

This second approach works well for a morning or evening sky. In Figure 134 a thin, wet wash of cadmium orange was laid over the entire area, deepening it toward the horizon with more orange. The largest cloud in the upper right was put into the moist sky with a slightly purple wash (ultramarine with a bit more vermilion than for a neutral gray). This was also touched into the wash along the horizon (Figure 135) to suggest distant cloud cover or haze. The sky was then allowed to dry completely.

The above-mentioned cloud wash was used again, but first the dry sky was misted with clean water from the spray bottle and allowed to stand until the shine disappeared from the surface. The

Figure 134

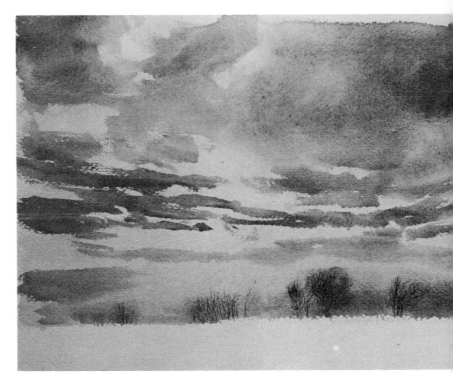

Figure 135

cloud masses were laid in, starting at the top and working down (Figure 135). The middle area happened to be a little drier, which was fortunate, since the long strings of clouds in that particular area came out practically dry brush, giving more definition and a change of pace. The area below them was still moist enough for those clouds to spread more, giving softness to the distance. With care, a hairdryer can be used to control drying in desired areas—this chanced to be accidental.

A little warmer wash (orange added) formed a blur for the tree tops. Brush-handling gave them character. Finally, the foreground, skyline, and trees were completed (see Figure 135). This complete sketch appears in color on page 144.

Figure 136

Cloud Layers

In Figure 136 the use of large clouds at the zenith and successively thinner layers of cloud suggest distance, while creating restful horizontals for a peaceful farm landscape. The blue was painted with a large brush and a load of color—ultramarine with a bit of vermilion at the top, then pure ultramarine. Lower down, cerulean was added to the ultramarine, then cerulean was used alone, and finally cerulean with a touch of cadmium yellow pale to give a greenish cast near the horizon. Some of the edges were softened with a damp, clean brush. The lower surfaces of the clouds received a wash of gray, deepening toward the bottom (Figure 137). Some edges were soft, some drybrushed—so that soft, hard, and drybrush or rough edges existed together, giving variety. Lastly a simple fall landscape was painted on the horizon.

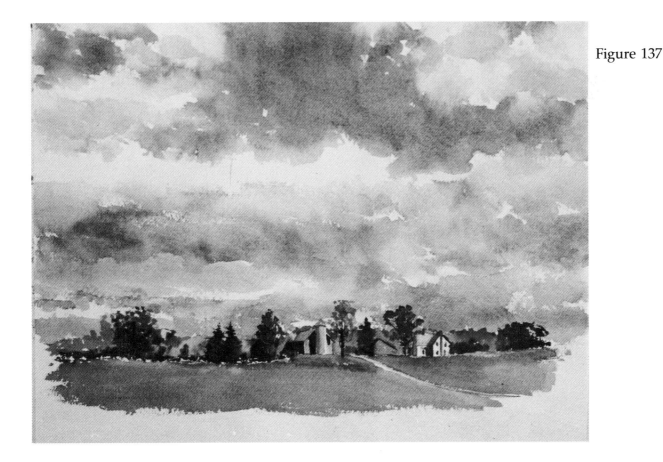

Figure 137

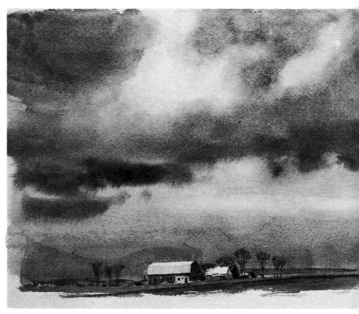

Stormy Sky Figure 138 Figure 139

In this stormy sky (Figure 138) the first wash was applied very wet so that considerable molding of values could be done. The extremely light areas were avoided, then moistened with clear water, blending all edges. In the upper sky a mixture of mostly ultramarine and cerulean with just a small amount of vermilion was used. In the lower sky, cerulean with a small bit of cadmium yellow pale was used.

At this point either of two methods is a possibility. You can go into the wet wash with a brushload of a rich mixture of ultramarine and vermilion, and form the tumbling clouds and the drippy ones just above the light horizontal. Or, if you prefer better control, allow the first step to dry completely. Then mold the clouds, do the lower ribbons of dark, and gently mist the entire sky with a little clear water so that soft blending occurs (Figure 139). When all is dry, the little farm scene below can be put in to complete the mood. For color, see page 144.

Winter Sky

In the final sky demonstration (Figure 140) a mixture of ultramarine, cerulean, and vermilion created a cold winter sky. A flat wash was laid down, carefully painting around the building area with its snowy roofs. A small amount of alizarin was laid into the damp wash near the horizon. While the wash was very damp, cadmium orange was also dropped in for the color of tree limbs and branches in late light. Then the surface was lightly marred with a slender brush-handle to indicate the tree forms in detail. As the washes dried, brush handle work on the main trunks and limbs left a light line, indicating light falling on these areas. Some por-

Figure 140

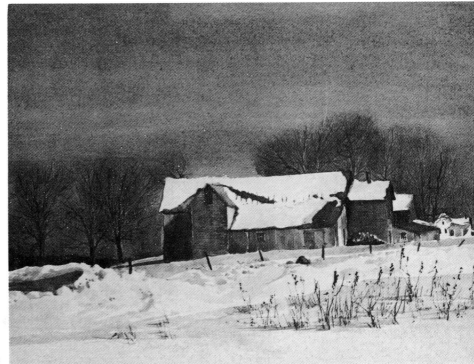

Figure 141

tions of bare roof were indicated as well as snow shadows.

In this second step (Figure 141) a dark horizon was added on the left and the buildings were completed, as were the snow shadows, fence posts, and weeds in the foreground. This appears in color on page 144.

A little snow scene is depicted in the first step (Figure 142). The scene was painted in strong enough values to allow for putting in the snowflakes without the painting becoming too light in value.

There are many subtle tones in snow, whether the sun is shining or not. By controlling these values, it is possible to center the interest by controlling which areas are left completely white. Here the largest area, the dark sky, was laid in together with tree forms in

this wet wash. Brush handle-work suggested trunks and limbs while the wash was still damp. The first values for the snow were started.

Next the darker values of the buildings were put in, isolating the snow areas so that they could be manipulated with subtle variations as the painting progressed.

Then a discarded Dexter #3 matt blade (which has a long, narrow tip) was used to pick the snowflakes out of the painting surface (see Figure 143). It is a rather tedious method, but makes a convincing snowfall with varying sizes of snowflakes to give depth. Since this method gives complete control, a few flakes can be indicated sifting down, a flurry can be put in, or a heavy fall, as desired.

Figure 142

Figure 143

In this series of demonstrations I will present a variety of subject material to show that any season can be depicted using combinations of the colors in a limited palette. The compositions are widely varied to demonstrate different procedures. Planning varies for each, dictated by the subject material itself. Studying these paintings step by step along with those shown earlier in the book and those contained in the portfolio which follows these five demonstrations should be of help.

The Summer Sky
Watercolor, 21½ x 29 inches

This early summer painting was prompted by a faded old barn on the edge of a nearby village. A coat of white paint had followed the red and it too was now chipping and washing off. The distant rolling hills of the peninsula were in direct contrast to the clump of birches, upright in the foreground.

Step 1. I made several exploratory thumbnail sketches, varying the size of buildings, raising and lowering the horizon and moving the birches around. Finally, settling on the one that seemed best, I made a color sketch about 6x8. Satisfied now with color, values and amount of sky, since this painting is mainly to demonstrate painting a sky, I penciled it on a sheet of 300-lb. D'Arches rough and began with the birch foliage first, following the procedure described earlier, working very wet with a load of color, light areas first on dry paper, then middle-green values, blending them frequently with the lightest greens. The deepest greens were feathered out for the delicacy of birch trees; frequent holes were left in the main mass of the tree, allowing for pieces of the trunks and branches to be added. The blue-gray of shadow on the birch trunks was put in next while the foliage was damp, to allow for occasional blending. All this was completed first so that the sky could be painted *around*—not under—the trees.

First and second values on the barn were washed in next as well as on the distant buildings. A basic yellow-green wash of cadmium yellow pale and viridian with an occasional bit of cadmium orange added, was brushed on the foreground, allowing for variations for foreground planes. The distant hills now received a flowing wash with the top edge drybrushed, using cerulean with a bit of viridian and vermilion added.

Step 2. Since I had now covered all but the sky area with wash, the clouds could now be painted freely around the trees, the top of the distant ridge and the peak of the old barn, without white areas elsewhere to distract in creating the sky pattern. A large brush loaded with a light value of gray—constantly varying a little from warm to cool—was used to paint in all shadow areas of the clouds first. These become long and stringy as they near the horizon. The top of these areas were now softened with a clean moist brush.

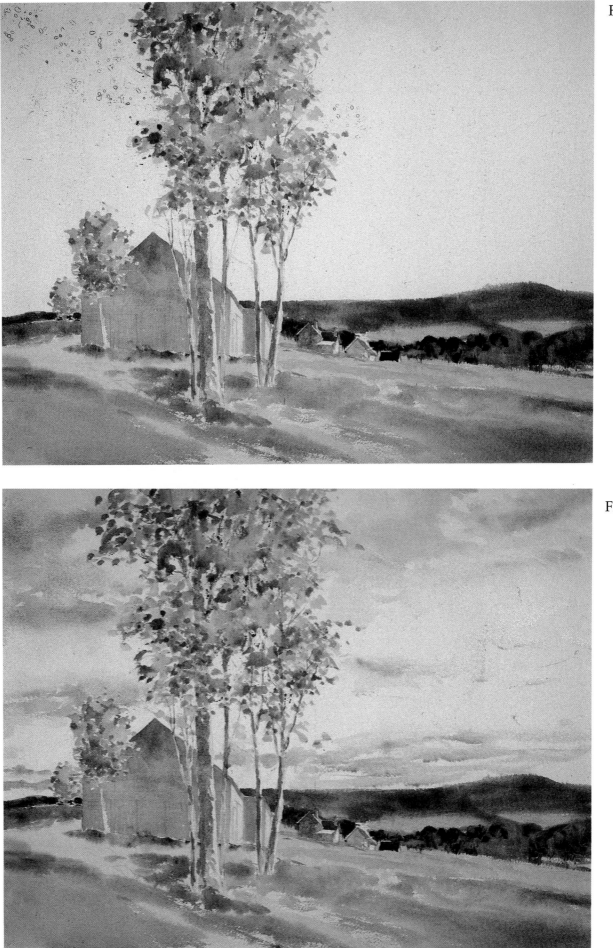

Figure 144

Figure 145

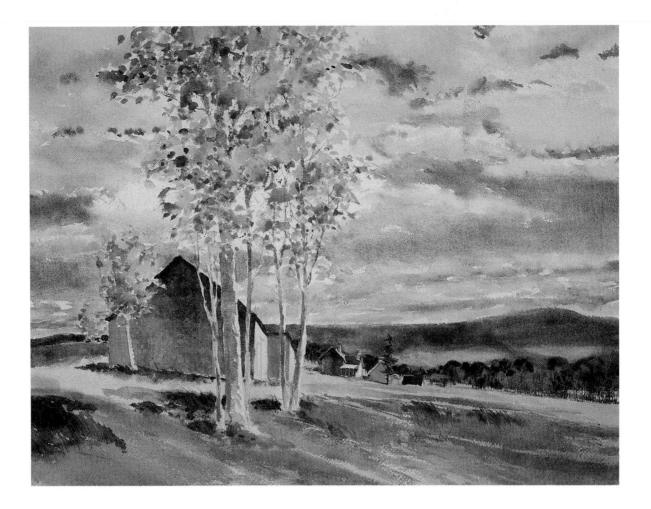

Step 3. The blues of the sky were added immediately using a mixture of ultramarine and cerulean for the upper holes in the clouds. These areas were allowed to blur frequently. Next, pure cerulean was used, followed by cerulean with a little cadmium yellow pale added toward the horizon. This entire sky—clouds and blue passages—was completed in less than ten minutes while all was moist and workable. Care was exercised not to flow color over leaf areas and color was also tucked into the holes in the foliage to carry the sky behind the trees. Plenty of bits of white paper were left to add light and sparkle to the trees. Now, with all major parts of the sheet covered, I turned my attention to developing stronger values, contrasts and lost-and-found edges. Values on the buildings were deepened and the foreground was broken up more by varying color and values.

Step 4. Detail came next, starting with the identifying black trunk markings on the birch, using a mixture of ultramarine and vermilion with a trace of cadmium orange. I took care to get a very irregular pattern of darks, using considerably different sizes and spacing

Figure 147

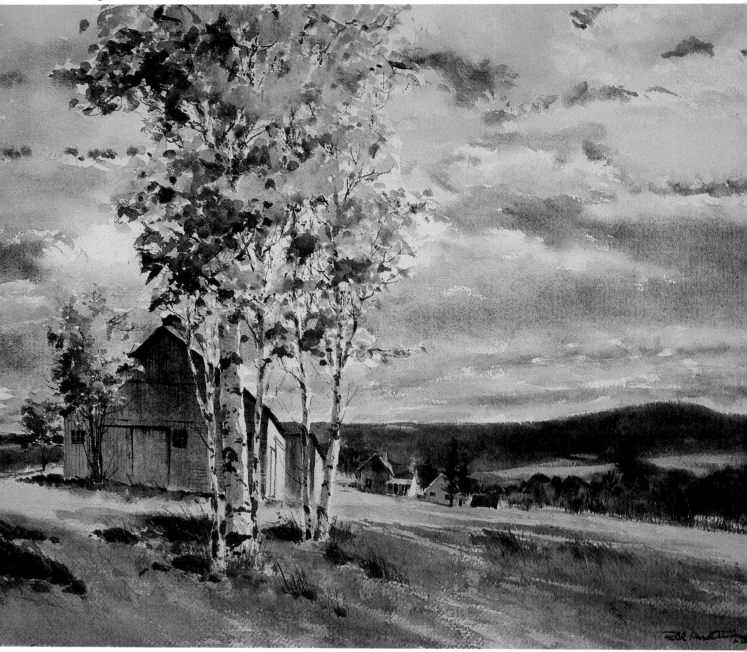

lest the trunks take on a mechanical look. These were also scattered up through the trees wherever the trunks or branches showed. Branches of a warmer dark (more cadmium orange and vermilion added) were pulled out among the leaves in convenient openings giving the characteristic lacy look of birches. Detail was added to the adjacent barn. Weed stalks and dark outcrops of rock were added to the foreground. It was now apparent that the trees, particularly the birches, needed some deeper greens in their foliage, so I mixed the value with ultramarine and vermilion, adding viridian for color, last.

Sweeping In, Mendocino
Watercolor, 21¹/₂ x 28¹/₂ inches

Step 1. The paper, a sheet of 300-pound D'Arches cold press, was washed off with a sponge and water and allowed to dry before the drawing was done. This makes a better working surface and must be done before penciling since washing sets the pencil lines, making it impossible to erase them. Liquid mask was applied to figures, holes through the rocks, and the grass fringe. This allows freedom in doing large washes. A light sky with even more light at the horizon was flowed on. A predominantly orange wash (a little ultramarine and vermilion added) was carried over the large foreground rock mass with some variation in value. Then the foreground was covered with a similar wash, and darker value and texture added for the grass. Brush handle work and directional strokes of dry brush helped with the texture.

The lower edges of the distant shore and offshore rocks were moistened with water. Then the light color for the rocks and shore was painted down to this moist edge, giving the soft edge of spray. Slightly darker values for contour were added as the light wash was drying.

Step 2. The edge of spray and distant rolling waves were moistened with clean water before starting the sweeping wash for the ocean. The light areas were a mixture of cerulean and viridian, the dark areas a mixture of ultramarine and viridian. Brush strokes all followed the flow of the water. This color was brought up to the premoistened edges for softness. A lighter value of the cerulean was laid into the moist areas within the white spray for soft passages of motion. Curling brush strokes gave roll to the distant wave. The horizon was washed with a lighter value of cerulean and painted down to the moist top of the wave. Deepest values of the sea water were added while the surface was still slightly damp so there would be no hard edges.

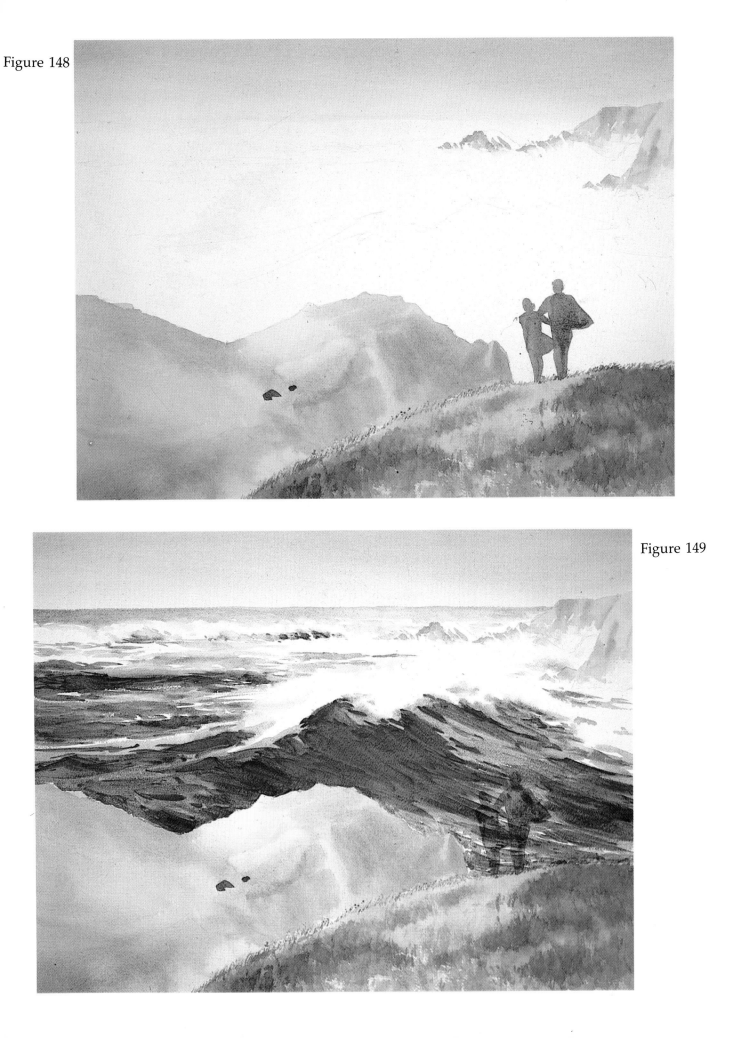

Figure 148

Figure 149

Figure 150

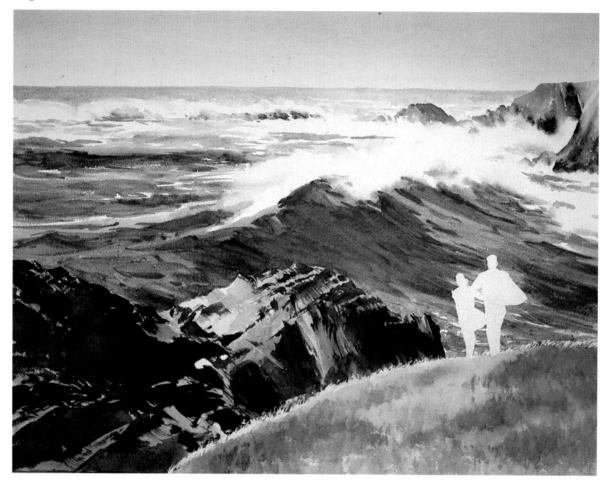

Step 3. The darker areas of the mass of foreground rock were now painted with a wash of ultramarine, vermilion, and a little cadmium orange for warmth. Changes in value, as well as a small degree of change in color, added interest and character. More light and more change were introduced near the figures but simplified, with larger passages of dark toward the left. Similar color, but lighter value, was used for the distant coast.

Step 4. Finally the liquid mask was removed. The color of the sea was added to the small holes in the rocks. The figures were completed with a loose treatment to match the rest of the painting. The grassy fringe of the hill was completed and the painting studied for any finishing details. A damp brush was used to soften the edges of the figures here and there to keep them from looking like cut-outs.

I originally painted this scene on the Mendocino coast (sans figures), inadvertently getting drenched in the process. The original was destroyed in a fire, but fortunately I had a number of good slides of the coast and the surf, and even a slide of the original painting, and decided to try it again, adding figures to give scale and help suggest the windy day.

Figure 151

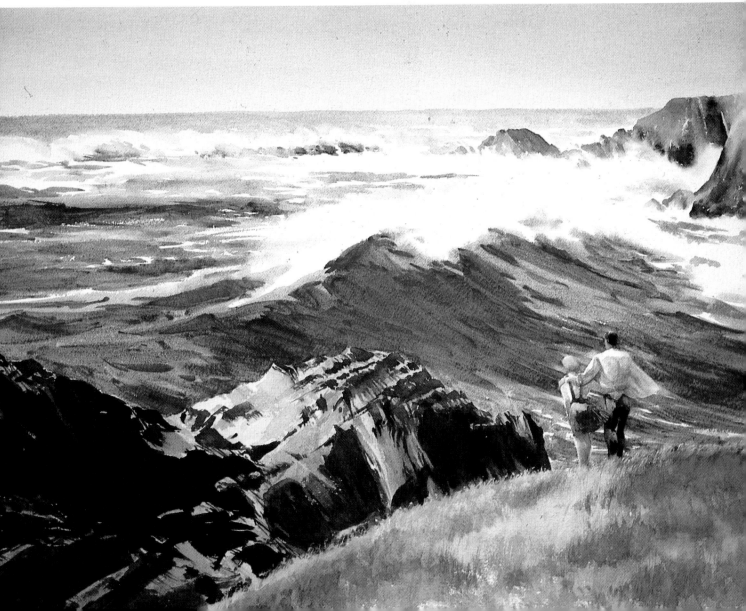

Up on Sugar Hill
Watercolor, 21½ x 28½ inches

This little hillside meadow surrounded by woods and some old fieldstone walls has always had a special charm, particularly in the fall when the distant blue ridge sets off the brilliance of the maples. After making several thumbnail sketches, I decided to add an old sugar shed and name it "Sugar Hill," thereby giving the painting a further dimension. The nearby overhead branches were added, since they seemed to increase the intimacy of the spot.

Step 1. To give the flooding warmth of fall, a thin wash of cadmium orange, slightly grayed, was laid over all of the field grass. The bright yellow and orange was splashed in for the mass of trees on the right. Working rapidly with lots of moist color, I washed in the ridridge with a mixture of ultramarine, cerulean, and a trace of vermilion. Into this wet surface splashes of cadmium orange, yellow, and vermilion were added at the lower edge, blending the fall color

Figure 152

136

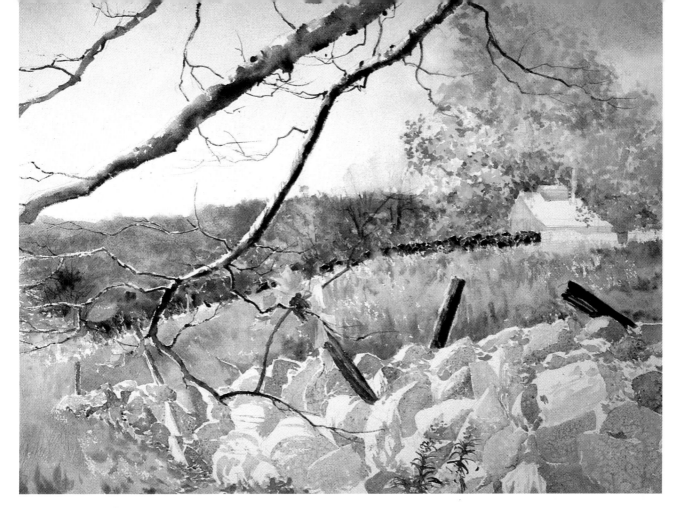

Figure 153

into the distance. The sky also was quickly added, allowing a soft blend along the top of the ridge, avoiding the limbs, and tucking it in around the colorful trees on the right. A trace of cadmium orange in the wash gave warmth above the ridge while more blue in the upper right suggested distant sky, as well as contrasting with the bright trees. Texture was added to the grassy field, bright leaves were added on and along the wall, and a simple gray wash was painted on the rocks, leaving adequate white paper.

Step 2. More color was added to the group of trees on the right . A little gray partially eliminated some of the white left for the shed. Darks were added for the distant wall. The overhead limbs received a varied gray wash as did the fenceposts. The nearby fenceposts were darkened as well as parts of the overhead limbs so that the strongest darks were now in the foreground. While the sky was still damp some vermilion with cadmium orange and ultramarine was blurred into the sky above the trees on the right to make a warm brown while a cooler wash was blurred in for tree forms along the ridge to the left.

Step 3. A varying wash, cool and warm, was added to the rocks of the wall. Once a gray is mixed on your palette with ultramarine and vermilion, it is easy in painting a wall like this to add a bit more orange with one brushful, a bit more blue with the next, or a bit more vermilion, so that your color and value keep changing slightly from stone to stone. A few rocks were left pure white or nearly so. Table salt was sprinkled into the wall; it gathers the pigment (if it is very moist) in little blotches and creates a nice stone texture. Finally, deep values and shadow were added to the wall. The woodpile by the sugar shed got a brown wash and detail was added to parts of the shed.

Step 4. Final color and shape were added to leaves on the overhead limb, and the leaves on and along the wall. Detail was added to the woodpile and I decided to make the sugar shed red with leaves partially obscuring it. Tree trunks were woven into the trees around the shed and along the distant wall. Saplings were put in at the left by the end of the rock pile, and a tall tree was added behind the overhead limbs to break up their outward motion and tie the

left side of the painting together. Limbs and branches were added where needed. The sugar shed received a metal roof of blue-gray with vermilion rust spots.

While doing the painting I have frequently tested it with a matt, closing out all side distractions to study it carefully. In the end, the important thing is to stop before overworking any part of it. Some weeds were placed in the middle ground. A little more bright color was splashed into the foliage on the right to loosen it up a bit, and the painting was ready for the signature.

Figure 155

Opening Up
Watercolor, 21½ x 28½ inches

Wooden gillnetters, used by commercial fishermen to harvest whitefish, are gradually being replaced by newer steel models. The old wood hulls have a special charm, though some scornfully refer to them as "old shoe boxes." In the spring the fishermen eagerly await the breakup of the ice so they can get out of the harbors and start setting nets.

Step 1. I decided to suggest this eagerness by having men carrying a box of nets out to prepare the "Margaret," as she sat among the last of the harbor ice, with the drifting ice beyond. Having carefully planned and penciled my design on a sheet of 300 pound D'Arches cold press, I began to work rapidly on a dry sheet with a large brush loaded with color, to create a big pattern. Floating clouds in a pale sky of cerulean and cadmium yellow came first, then ultramarine for the distant water with the white of the paper for floating ice. The large triangle of quiet water came next, then the entire shadow side of the boat and the reflection—one gradually deepening value, washed in with a mixture of ultramarine, cerulean, and a bit of vermilion. A light and dark figure was blocked in, a warm dark suggested the dock, a wash of cadmium orange with a bit of ultramarine and vermilion represented the wet sand in the foreground, and a gray dominated by orange created the far shore. A mixture of ultramarine and vermilion made the value to which viridian was added for the deep green trees along the far shoreline. This blurs slightly into the warm gray, giving distance.

Step 2. The shadow side of the boat was deepened toward the lower part of the hull and toward the rear, forcing the front end forward. Values were also deepened considerably in the reflection. While this was still damp, scrubbed and chipped paint was indicated, and the name "Margaret" was added. The lower hull received a wash of dark green (prepared as for the evergreens mentioned above). Spots of dark gave accent to portholes, open doors, and windows of the pilot house. Smokestacks and running lights were added. Reminder: from the pilot's viewpoint the red is on his left and the green on his right!

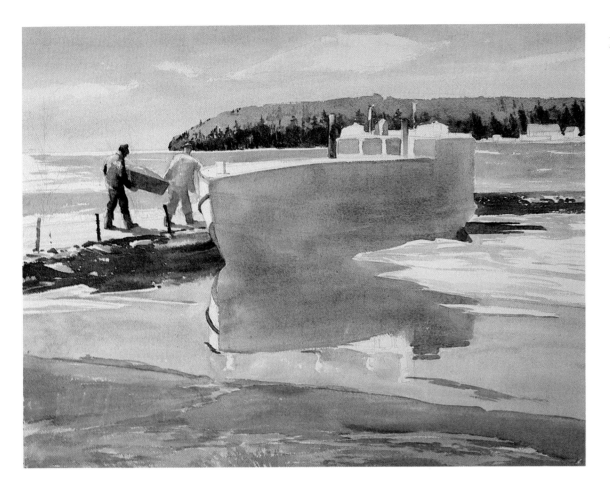

Figure 156

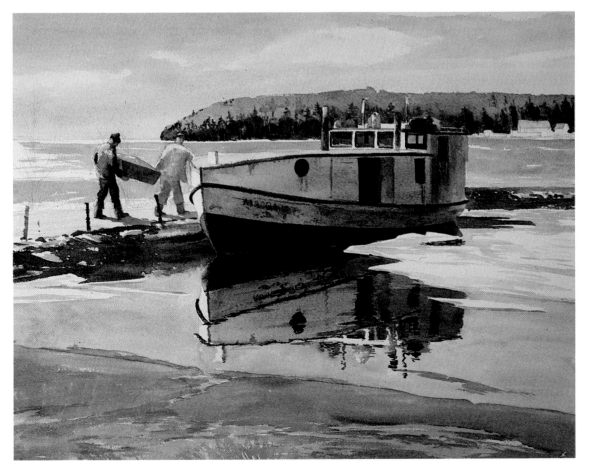

Figure 157

Figure 158

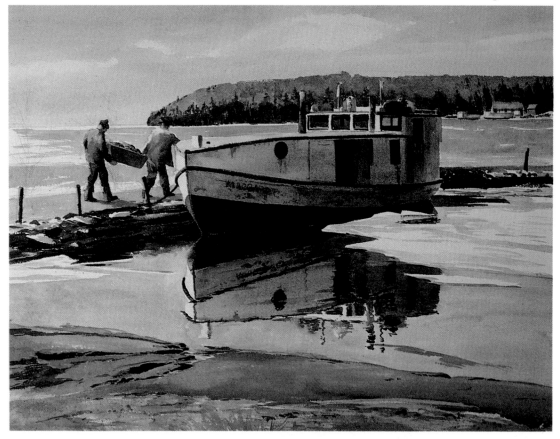

Step 3. Deep values were added to the dock, suggesting more detail. The figures were darkened in value. The distant dock, fish sheds, and boats seemed to need slightly more detail. The old posts along the dock were strengthened and at this point I decided there should be one behind the boat, closer to the margin than to the boat. A dark brown, a mixture of ultramarine, vermilion, and cadmium orange, was now used to put in shadows for rivulets on the shore, wet edges to the sand, and similar details. The same color was used for a hawser to tie the boat—about time! A lighter wash of the same color gave a little more shape to the sand.

Step 4. Studying the wedge of open water beneath the boat, I noticed this area needed to be a little deeper in value as well as slightly warmer, so I mixed a thin wash with cerulean and a bit of cadmium yellow pale, and with a large brush ran a quick wash across all but the snowy ice and white reflections. The improvement was noticeable. Somehow it looked more mirror-like. Then yellow grass was added on the far side of the dock as well as some slender saplings, put in with a mixture of cadmium orange and a little vermilion and ultramarine. The ends of the branches were blurred with a damp brush. Reflections of the posts, saplings, and figures were added to the still water. The wedge of water and ice containing the reflections actually has become the focal point. Reflections frequently are an exact duplication of the object, but I prefer some distortion, some fracturing from ripples and a deepening of the value of the reflection.

Figure 159

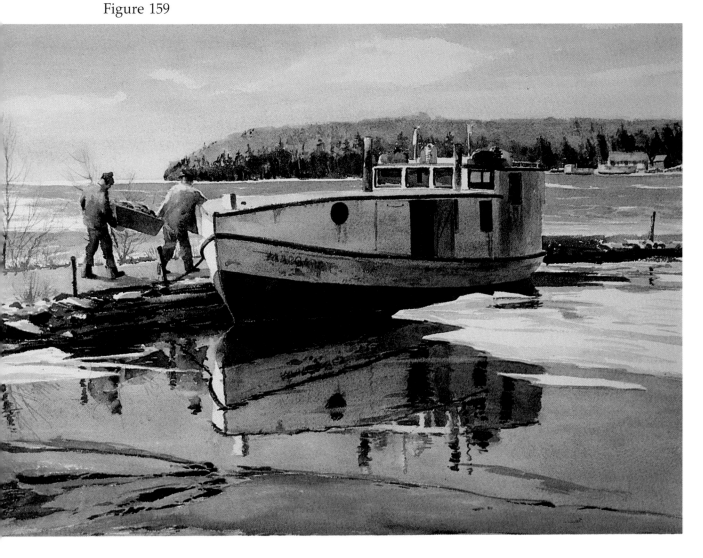

These sketches show in color the effects discussed and demonstrated on pages 116-125.

Figure 160

Figure 161

Figure 162

Figure 163

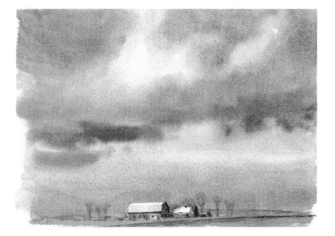

Figure 164

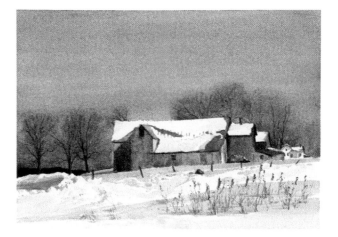

Figure 165

Figure 166

Up Through the Woods
Watercolor, 21½ x 29 inches

Step 1. The scene was planned as usual through a process of several thumbnail sketches, with attention to having a large area almost pure white. It was then penciled lightly on a 22x30-inch sheet of 300 pound D'Arches rough paper. Liquid mask was applied to isolated whites contained in large areas of wash. Masking tape was used on a barn roof and a house back in the woods—an easy solution where simple angular forms are to be masked. The paper was now moistened by lightly passing over it with a wet sponge. Any traces of glisten were removed with the sponge. Then a wash of ultramarine and cerulean, with a small amount of vermilion to gray it slightly, was flowed freely over the upper area of the woods and all shadow areas of the snow on the ground and evergreens. The trunk areas were avoided and any excess bleeding of color into them was blotted up. (Use either a damp brush or a strip of soft blotter.) Darker variations in the wash were added adjacent to large, white areas, increasing contrast.

Figure 167

Step 2. More values were added in the large areas of blue wash, particularly the top quarter of the background, plus darker value on shadowed trunk areas, some mounds of snow in foreground, and some cast shadows. Branch forms were squeegeed out of the damp wash with a brush handle. A mix of ultramarine, vermilion, and orange (to produce a dark gray) was now used to indicate distant trees. The masking tape was removed from the building and the nearer trees were then painted in, together with a simple indication of the buildings.

Figure 168

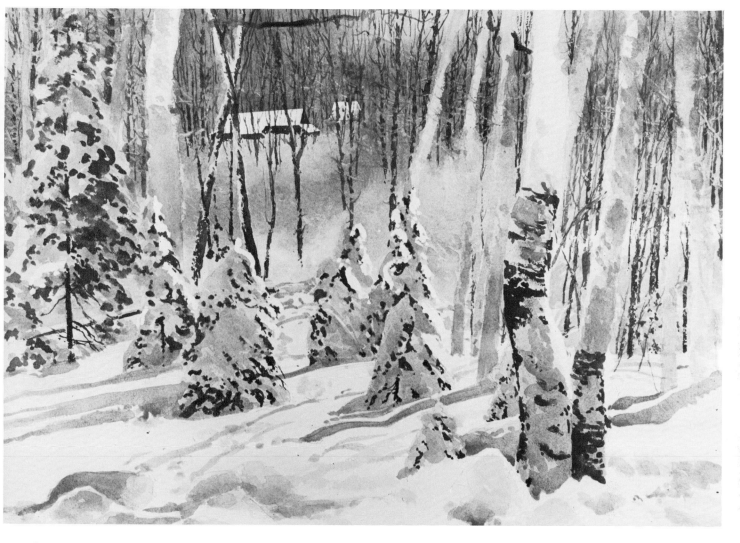

Step 3. A mixture of dark green, achieved by mixing ultramarine and vermilion, then adding enough viridian to make a green, was used on the evergreens, allowing branches to peek out from beneath masses of snow. A warm gray mixture of ultramarine, vermilion and some cadmium orange has been added to birch trunks where there is no snow clinging. This change in color distinguishes the light bark from the snow on the trunks. The liquid mask was removed from the evergreens, bringing out the whites of sunlight on snowy trees. Detail was given to the nearest trees. These were completed first since they carried the most detail. More distant trees carried less detail.

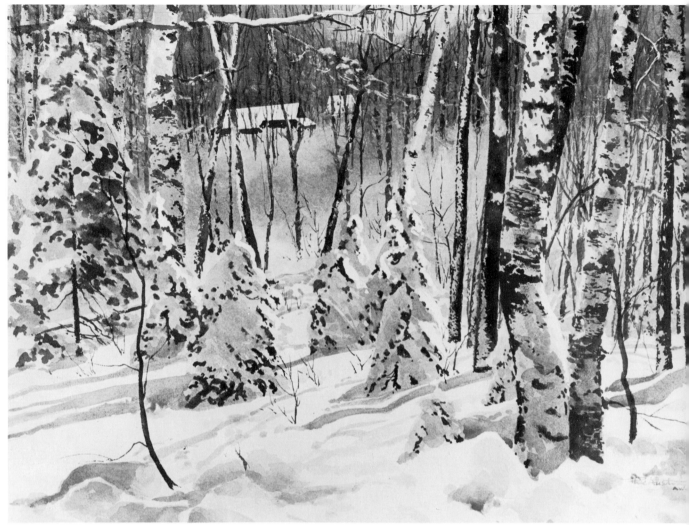

Figure 169

Step 4. The last of the liquid mask was removed, revealing snow-laden limbs of birches. Limb detail was added with dark gray, which was also used to place saplings in the foreground and twigs sticking up through the snow. A few slender trees were added in background and a final decision was made to deepen the farthest woods with a wash of blue, grayed with vermilion and cadmium orange.

Portfolio of Paintings

I am frequently asked, "How do you decide what you are going to paint?" or "Why are you doing a painting of that?"

Sometimes this is a hard question to answer. My reason for doing a painting has a great deal to do with how I feel about the way a field lies across a hilltop and disappears around a woodlot, about the sturdiness of an old log cabin standing alone against the woods, or a hundred-year-old stump, gray with age and rusty with decay. It may be scattered Queen Anne's Lace and Tyrolean Knapweed surrounding it that moves me to paint or the way fresh snow has drifted against a weathered, sagging building. In other words, I have a gut feeling that I'm looking at a good subject.

Teaching workshops has made me aware of the value in students learning not only the ways in which other artists work, but to

see specific things demonstrated such as the painting of water, re-flections, cloudy skies, foregrounds, trees—in short to watch a painting in progress from start to finish. It is also helpful to review a variety of paintings together with comments regarding the choice of subject, ideas employed, and procedure. That is the reason for the following pages, a portfolio of paintings accompanied by such captions.

Figure 170

Collapsing Dream
Watercolor, 21½ x 29½ inches
Collection of Elmer Fox & Co.

This old house stands on Catamount Mountain in New Hampshire. The lights and darks, as well as trees, were adjusted for emphasis. The old, shattered stump was invented for a partner in the collapse.

Figure 171

This log cabin, long deserted with its accompanying sheds, has served many uses in my paintings. I have remodeled it on occasion, painted an old wagon in the yard, and put it in a fall or a winter setting, as seen here.

Figure 172

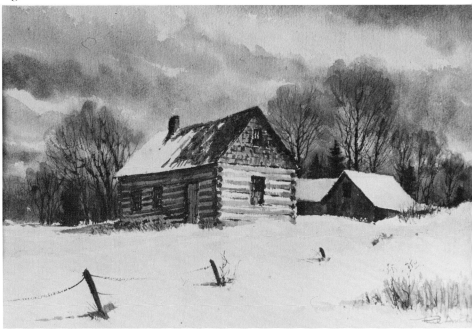

Left in the Cold
Watercolor, 14x21¹/₂ inches

This painting, done as a classroom demonstration, shows the use of dark against light—note the cabin roof, light on left, dark on right, with the harlequin effect of the light end of the cabin. Details were minimized in the sheds behind, while trees on the left of the cabin blended with the cabin for a lost edge. The light end of the cabin also is nearly a lost edge with the snow, in contrast with the stark division between snow and the rear shed. The sky is low hanging, snow clouds suggesting cold temperature. The foreground has little change in value and limited detail so that it does not compete with the cabin details.

Figure 173

Evening, Ephraim Harbor
Watercolor, 11½ x 15⅝ inches

Flanking darks and central negative space emphasize the boats at their moorings. The late light and sweeping horizontals create a cool, peaceful atmosphere.

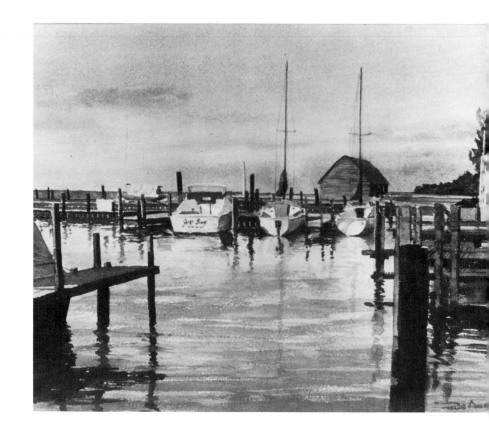

Figure 176 ▶

Return from an Early Morning Catch
Watercolor, 21½x29 inches
Collection of Delphine Olson

This is in direct contrast with the painting above. The gillnetter slips quietly along, followed by hungry gulls. The mirror-like water reflects the sun burning through the morning haze. The slanting cloud, and the reflection of sun and cloud put the silhouetted boat in a separate area, leaving the nearby point and the distant island behind. The darker foreground and the dark above the cloud focus attention on the boat.

Figure 174

90°, Sugarloaf Key
Watercolor, 14 x 21½ inches

Strong shadows and sunswept surfaces from light directly overhead suggest the heat. The dark silhouette of lobster traps stacked against the sky adds to the activity of the scene.

Shrimp Boats, Mt. Pleasant, North Carolina
Watercolor, 21x29 inches
Courtesy of Gallery One, Florida

The shrimp boats lined up at the left with their jagged pattern of white areas and the busy rigging suggest eagerness to be in motion. The "Sunny Boy" is the only one completely visible with all its gear and becomes the center of attention.

Figure 175

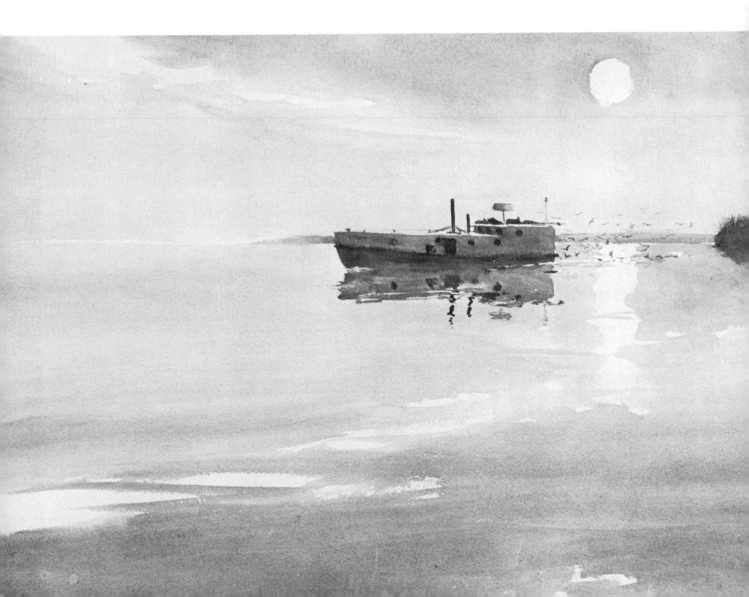

The Ancient Stump
Watercolor, 11½ x 15⅝ inches
Collection of Mr. and Mrs. John Rosberg

Since the stump was the center of interest, I really "zoomed in" on it. Masking kept the flowers untouched until the stump was completed. (Some masking was used for distant flowers as well.) A loose background and sky were washed in. When this was all dry, masking was removed and flower detail completed.

Figure 177

Net Markers
Watercolor, 15⅝ x 11½ inches

This pile of net markers made an interesting corner with gray shingles as a background and a yellow-green bush partially surrounding them. Note the loose wash character and variation in the window panes.

Figure 178

Figure 179

Lobster Gear—Big Pine Key
Watercolor, 21x28 inches
Collection of Mr. and Mrs. Dick Shaft

*Light from the right helps add motion
to the left, as does the blowing palm
tree. The clouds and distant keys
blurred on the horizon increase the
feeling of wind. The rusty drum as
well as the scatter of wooden floats re-
lieve the monotony of multiple traps.
The orange band around each white
float identifies ownership.*

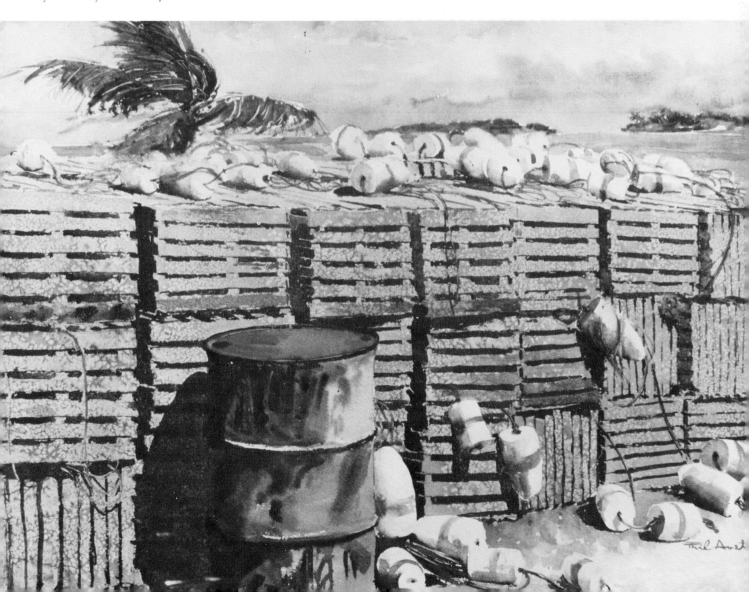

November Washday
Watercolor, 21½ x 29½ inches

This simple house sitting in a corner
woodlot somehow has a special appeal for
me. I've painted it in different seasons and
weather.

Limbs coming into the picture from the
right give depth. Bare maples and birches on
the left push the house back farther. A series
of warm grays were used—ultramarine blue,
vermilion, and cadmium orange. A few
bright red and orange leaves were scattered
in.

I decided to put in a line of fresh wash-
ing together with the laundress to add inter-
est and connect the house and the old barn.
It created interest all right—nearly started a
scandal for old Cap Larsen who lived there
alone!

Figure 180

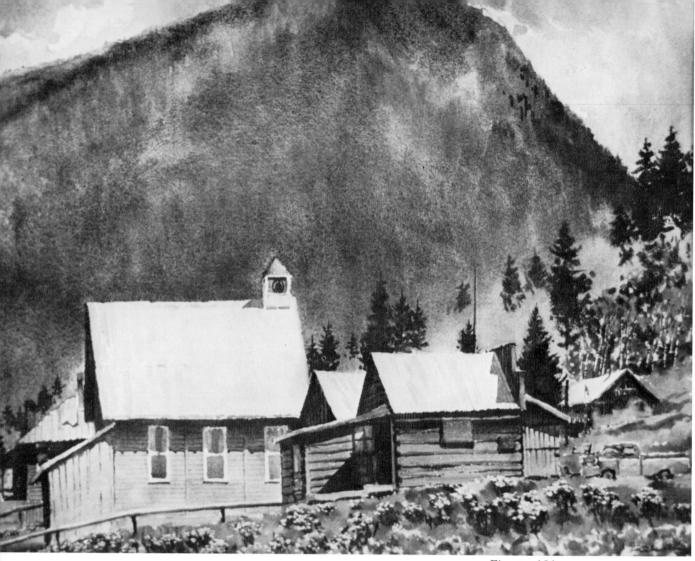

Figure 181

Hahn's Peak Village, Colorado
Watercolor, 21¹/₂ x 28¹/₂ inches

This was a revision of a painting done on location. In the first one the entire peak was contained within the painting. Closing out the sky made the mountain loom larger.

Figure 182

Lonesome Farm
Watercolor, 11¹/₂ x 15⁵/₈ inches

This and the painting above were discussed in the section on various types of lighting.

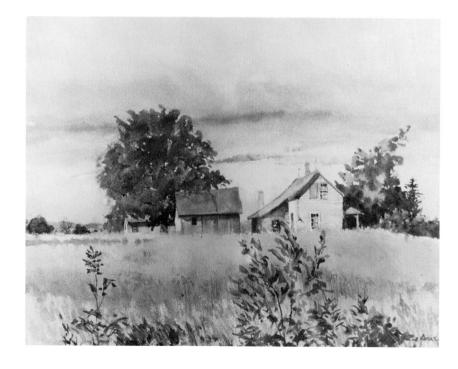

Figure 183

Evening Light, Lost Lake Road
Watercolor 21½ x 29 inches

*Simplified lights and darks dramatize
these old buildings and the sturdy
birches beside them. Note the building
up of light against dark at the build-
ing corners. The foreground has con-
siderable texture in contrast to the
buildings.*

Figure 184

Fishing at the Old Saw Mill
Watercolor, 14 x 21½ inches

*The foreground, approximately two-
thirds of the painting, is handled very
simply so that it becomes negative
space, leaving the old mill the center
of attention, even to pointing out the
little figure passing the dark opening.*

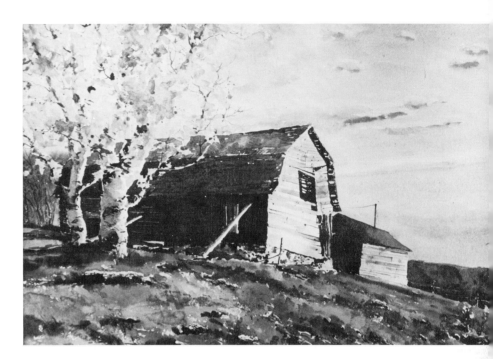

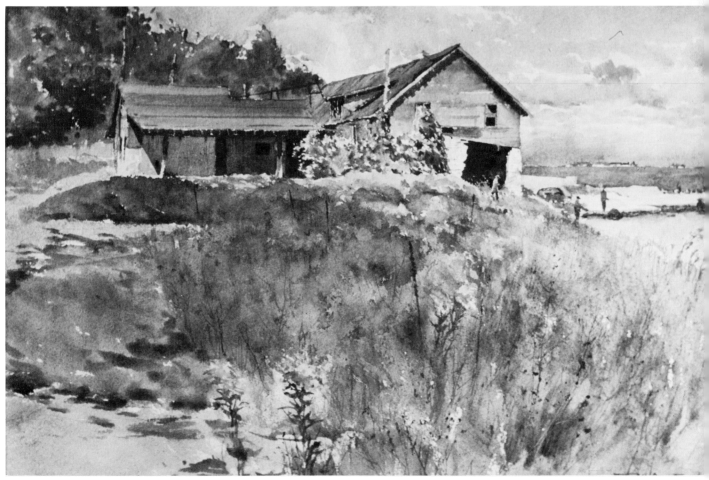

Figure 185

East Window

Watercolor, 21x28 inches
Collection of Mrs. Phil Austin

*This old log cabin exterior showed a varied
history, battens, siding, window trim, deser-
tion, and gradual deterioration of the origi-
nal logs. An old lace curtain remained in
the sole window on the east wall. I couldn't
resist adding to the story by placing a pot of
chrysanthemums in that east window. Now
the old place was the humble residence of a
cheerful soul, who loved beauty. The logs
and siding were painted with a neutral gray
of ultramarine and vermilion, the siding be-
ing a little deeper in value than the logs.
The width of wood covering the thick wall,
seen through the window, was painted a
warm brown achieved by adding cadmium
orange and more vermilion to the gray
wash. A little green foliage showed above the
roof of green shingles. The mums were
painted a bright yellow with cadmium pale.*

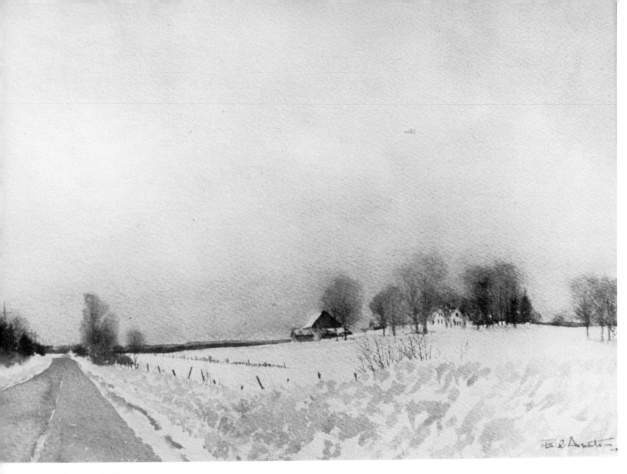

Figure 186
Winter on Rt. 57
Watercolor, 21½ x 29 inches

*This winter scene uses a large amount of
negative space to emphasize the isolated
farm. A minimum of shadow (cerulean with
a touch of vermilion in it) was used along
the snow bank. In contrast, the sky is a
large graduated wash of cadmium yellow
pale with just a hint of cadmium orange to-
ward the horizon. The buildings are very
simply done with all the trees blurring
slightly into the wet sky. The distant ridge
is a combination of a darker blue-gray ridge
backed by a cerulean ridge with a hint of
white here and there. It serves as an arrow
coming from the left into the farm buildings.*

*This photo up on Collier's ridge has
given me inspiration for several paint-
ings. The one on the right is perhaps
the most successful.*

Figure 187

Figure 188

Door County Winter
Watercolor, 21½ x 29 inches
Collection of Northwest Mutual Life Ins. Co.

*This painting was composed of many of the things that make the Door County area
what it is. Sturdy old maples, stone walls with snow wrapped about them, pine trees,
old farm houses, log barns, rolling countryside with blue on distant ridges. I used the
rather dramatic shadow to put the scene in deep winter, using a rather intense ceru-
lean and ultramarine mixture. The barn and house were done with soft grays. The
middle distant trees were blurred into the warm sky, which was mostly cerulean with
some cadmium yellow pale added to the sky where the nearer tree limbs blurred into it.*

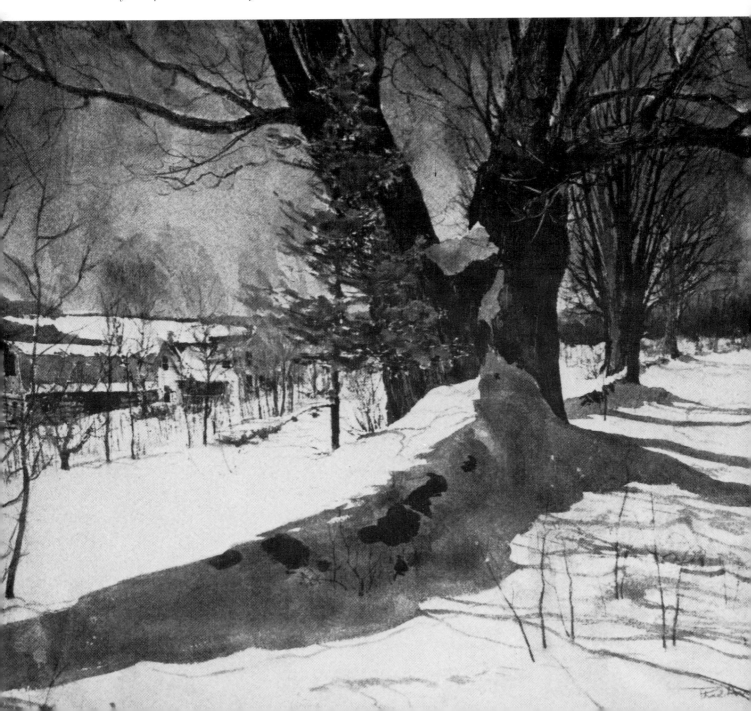

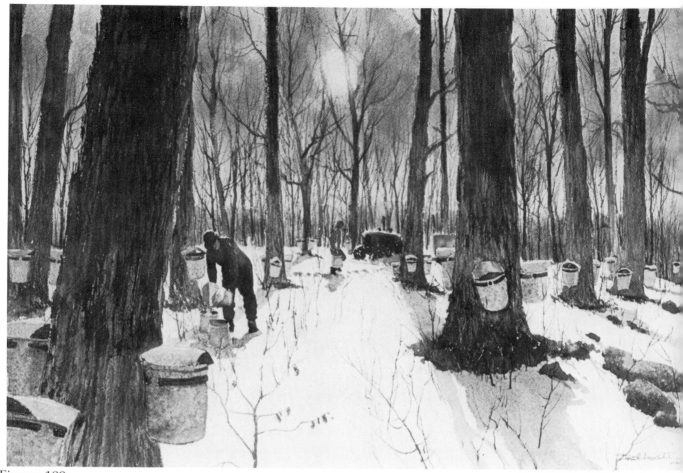

Figure 189

Morning in the Sugar Bush
Watercolor, 14 x 21½ inches

Having helped the neighbors a bit in their sugar bush as a kid, I take real pleasure in doing frequent paintings of this old and interesting operation. Brush handle is a real aid in doing maple tree bark, and salt in the wet wash on the sap buckets really mottles it like galvanized metal. The perspective of sun and shadow makes for interesting composition.

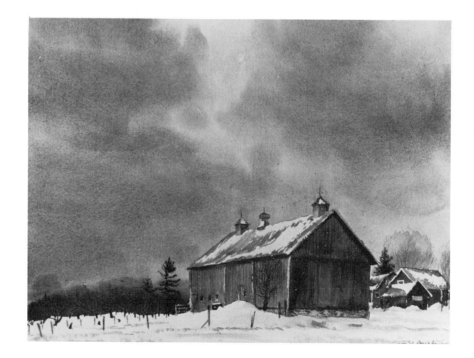

Figure 190

January Sky
Watercolor, 11½ x 15⅝ inches

This rather moody painting was discussed earlier in considering types of lighting.

Full Moon in December
Watercolor, 11½ x 15⅝ inches
Collection of Thomas Zuchowski

At 4 a.m. I looked out at my neighbor's place bathed in light. That morning, using strong values of blue-gray and dark greens (ultramarine blue and vermilion with viridian added) I painted the remembered beauty.

Figure 191

Figure 192

More Snow, Garrett Bay Road
Watercolor, 14 x 21½ inches

Painting on location, soft edges were left for trees against the sky. Values were intensified to allow for white flakes which I later picked out. (See page 126.)

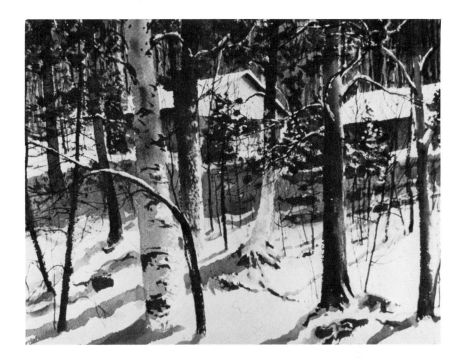

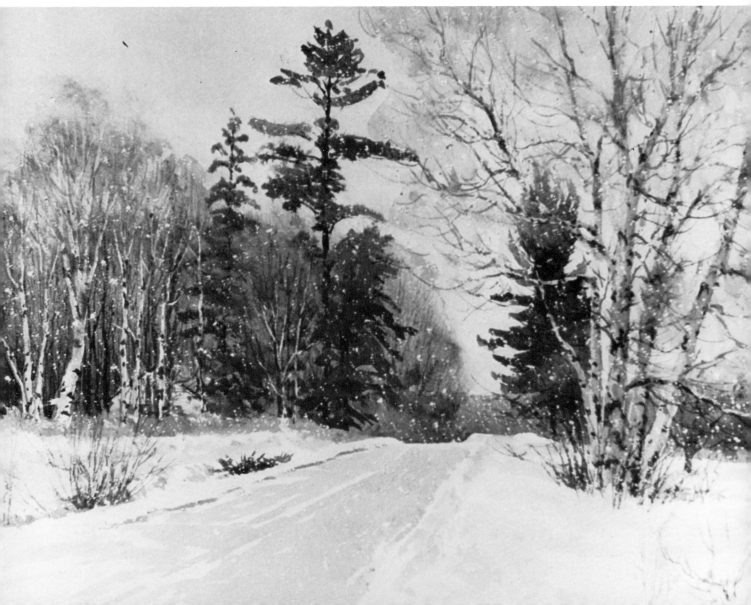

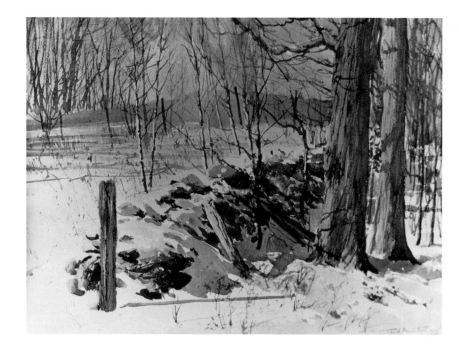

Winter Boundary
Watercolor, 11½ x 15⅝ inches

Stone walls and late afternoon shadows on drifted snow are marvelous together with shaggy barked maples and birch samplings. The color scheme is simple: cool grays and a warm sky, painted direct on location in a race with the light.

Figure 193

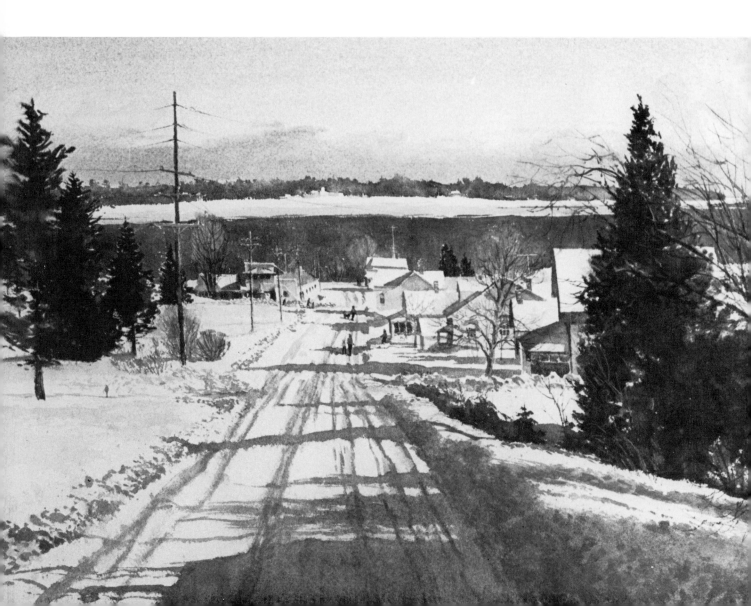

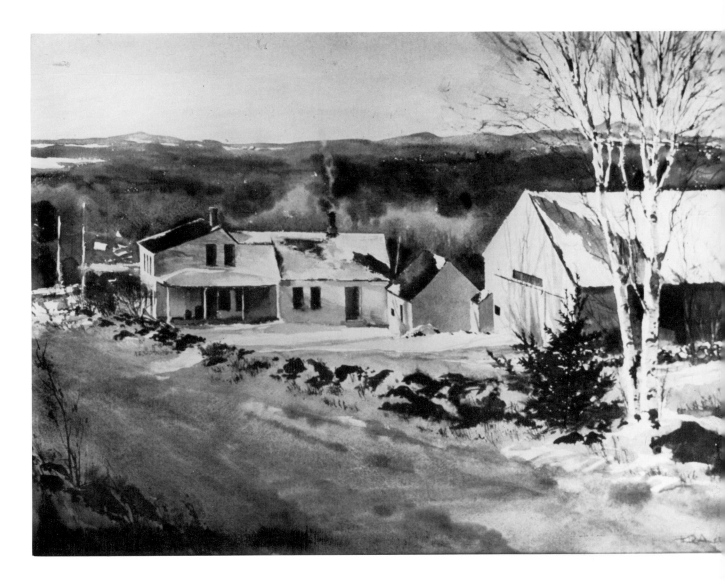

Blue Harbor
Watercolor, 21¹/₂ x 19¹/₂ inches

On this sunny day the partially frozen harbor was an intense ultramarine blue. The shadows were a rather intense mixture of cerulean and ultramarine, making the rich green of the pines stand out. The tops of the bare trees were a warm gray in the sunlight, and the houses formed an interesting pattern of overlapping shapes. Bright flashes of red, yellow, and green were used as jackets on the little figures. The far side of the harbor was warm by comparison with the blues. The sky had a purplish-gray cloud bank on the horizon. The horizontals, combined with the perspective of the road, carry the eye out to the harbor.

Figure 194

Farm on Catamount Mountain
Watercolor, 21x29 inches

The building here is spotlighted by the late sun. The subdued road in shadow accentuates this as do the dark wooded hills of the distance. The birch on the right bridges foreground, middle, and background. Contrast is emphasized at building corners. Horizontal shadows establish middle distance.

Figure 195

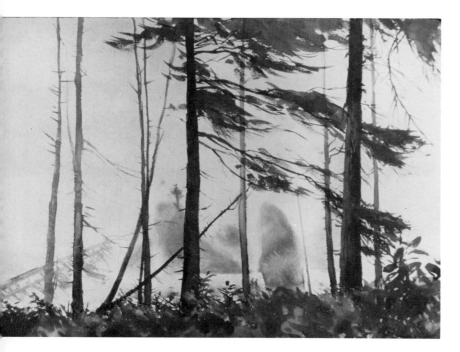

Figure 196

Fog at Ruby Beach
Watercolor, 21x29 inches
Collection of Mr. and Mrs. Patrick Riley

*In this West Coast painting a cool
gray wash was laid over the entire
sheet. Then the faint "stacks" were
washed in as well as portions of the
tree trunks and branches. The fore-
ground was done wet in grays and
greens as the surface dried somewhat.
Finally, the nearest trees were painted
onto a surface practically dry.*

Figure 197

Afternoon Shower
Watercolor, 11½ x 15⅝ inches

*This little watercolor was done very
fast and direct with a variety of
greens and values, easily achieved
with the limited palette. The gray
storm cloud and the rain-streaked sky
were put in wet.*

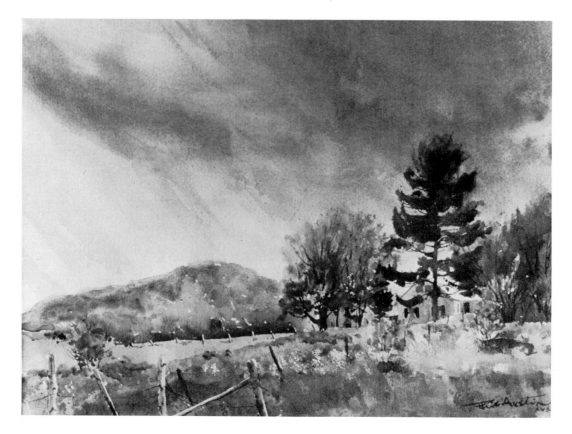

Figure 198

The Turtle-Flambeau Flowage
Watercolor, 21½ x 29 inches
Collection of Employers Insurance of Wausau

The rocks were done with a mixture of ultramarine and vermilion with the red in predominance. The dark areas were put in with a very rich wash of this mixture. Cerulean and a little vermilion created the blue-gray shadows of the white water, applied while the rocks were still damp so that blending occurred in some areas. Edges of these shadows were softened in places with clear water. Some bits of liquid mask provided for the glimmer of sky here and there. The lighter greens were cadmium orange and ultramarine blue with cadmium yellow pale added in some areas. While this was still moist, deep greens, made with a dark value of ultramarine blue and vermilion, with viridian added, were washed in and allowed to blend freely with the lighter greens. Finally, the masking was removed and the little lights received a blue sky wash. Brush strokes conformed with direction of motion.

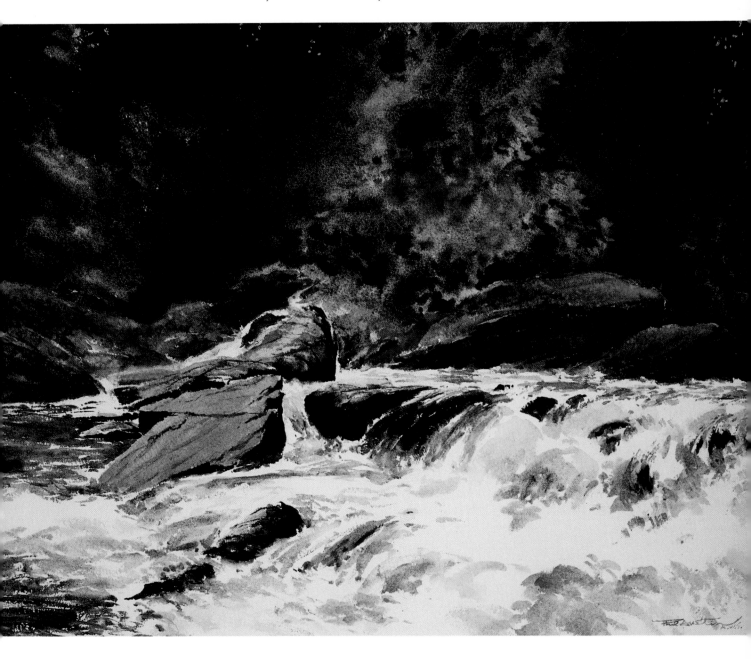

Figure 199
The Big Swale, The Ridges Sanctuary
Watercolor, 11½ x 15⅝ inches

The water, grass, and sky were all worked very moist. The details were added when about dry. The reflection here is the major point of interest and is actually negative space.

Figure 200
Tide Marsh, Mt. Desert
Watercolor, 14 x 21½ inches

This was painted on a dry sheet with very wet washes. Bright foliage came first, then the distant mountains and sky all blending, then the tawny marsh grass values. The water and reflections came next, and the foreground grass last.

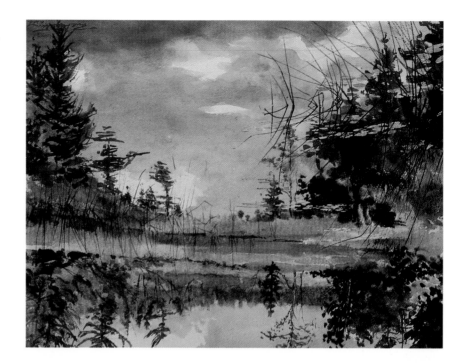

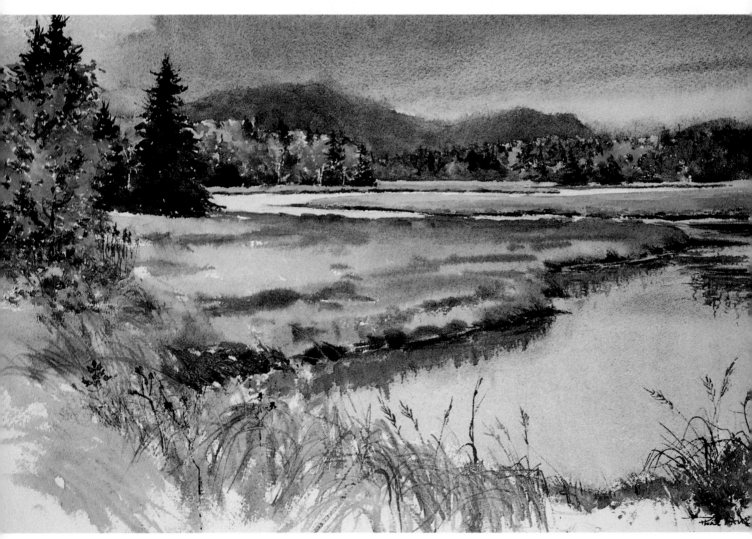

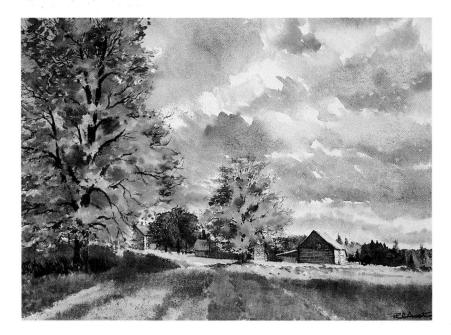

Figure 201

Fleeting Sun

Watercolor, 21x29 inches

*First trees were painted, then fore-
ground all in the lightest color. Build-
ings and distant woods came next,
then sky. Clouds suddenly darkened
the foreground and left a ribbon of
light around the buildings. The effect
was so dramatic that I hastily dark-
ened the foreground to match it.*

Figure 202

First Track

*Watercolor, 21½ x 29 inches
Collection of Kierney and Trecker
Corp.*

*Liquid mask was applied to hold areas
for snow on the branches. The sky
was then washed in and all the green
mass of trees. The snow shadows were
a mixture of cerulean and a little al-
izarin, applied rapidly and very wet.
A bit of mist from the spray bottle
when they were complete caused the
alizarin to float slightly, giving a pink
glow to the landscape.*

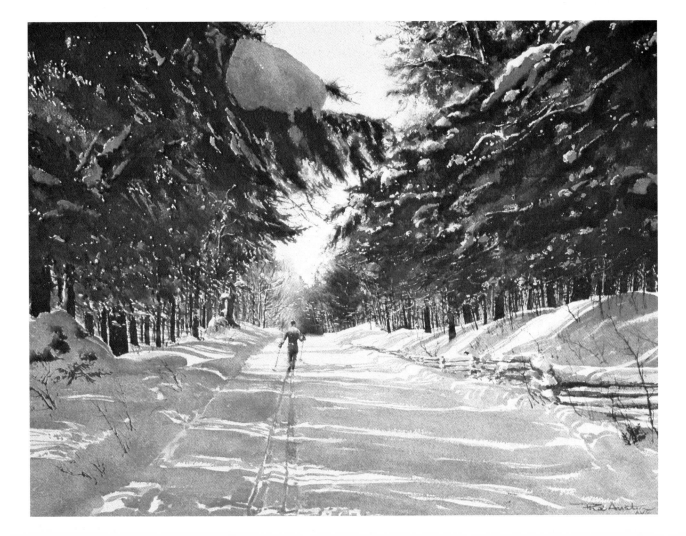

Figure 203
Returning Gillnetter
Watercolor, 21x29 inches
Collection of Mr. and Mrs. Lee Wendell

When a fishing boat is escorted by a lot of gulls, it usually means a good catch since it indicates the fishermen are still cleaning the catch. Liquid masking held white for the gulls and details of the boat, and allowed freedom in doing the sky rapidly.

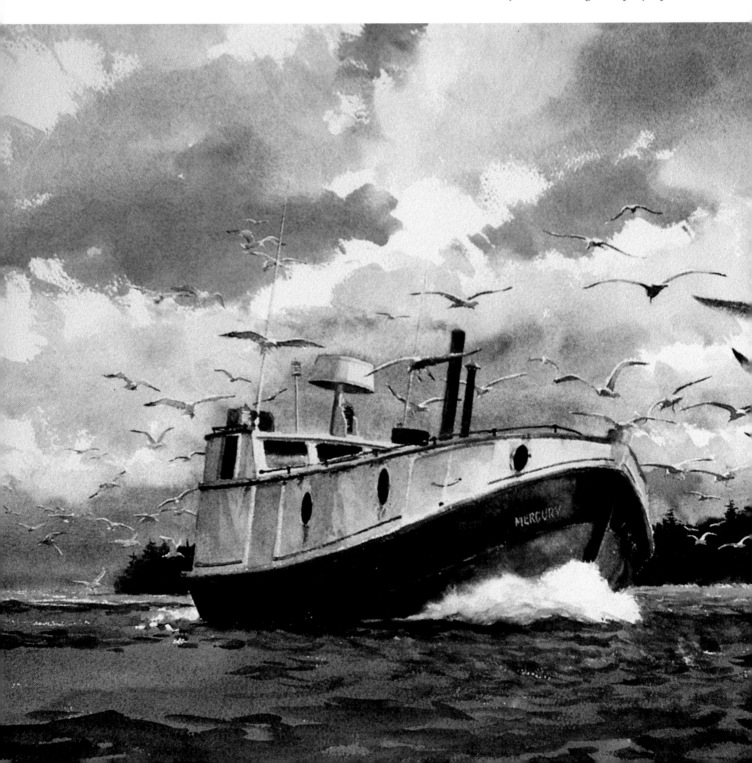

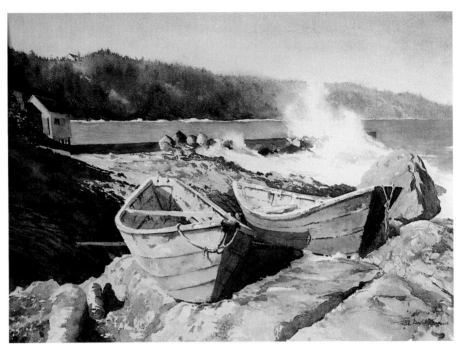

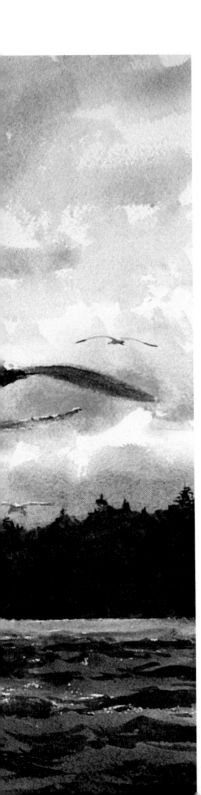

Figure 204

High Tide, Sandy Cove, Nova Scotia
Watercolor, 21x29 inches

The spray was tremendous at high tide, so I placed two colorful dories on the rocky shore and used the strong shadows strategically to work for a strong composition. Moist edges on the spray area were painted into for softness. The dock and the distant shoreline provided strong horizontals in contrast to the spray breaking upward across them.

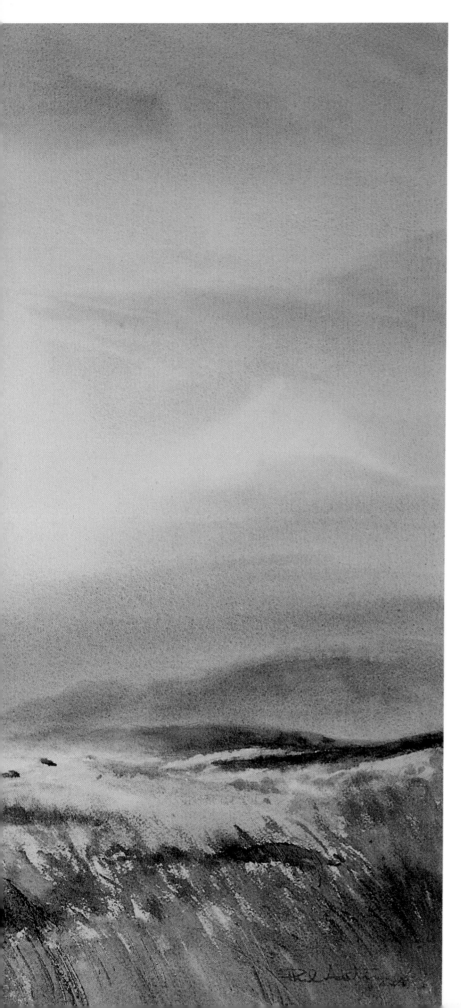

Figure 205

Pacific Solitude

Watercolor, 21x29 inches
Collection of Mrs. Phil Austin

This painting was done wet-on-wet. The beach grass was dry-brushed into a damp surface and limited brush-handle work was done. Changes in value and color were also brushed in damp. When the painting was dry, a few details were added including the hiker (who is myself), since this is sort of self-portrait of my love for the sea beaches.

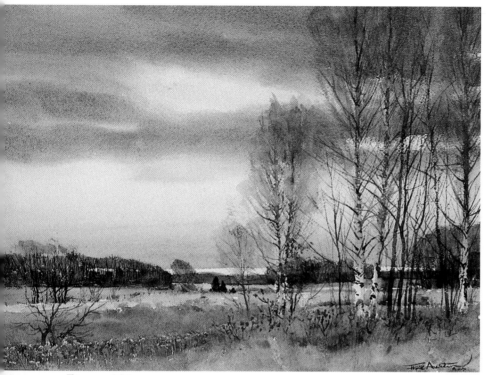

Figure 206

Morning Silver, Rowley Bay
Watercolor, 11½ x 15⅝ inches

For a brief moment as I painted, the sun came through a rift in the clouds and turned the distant water to shining silver. It gave life to the soft grays and browns of fall.

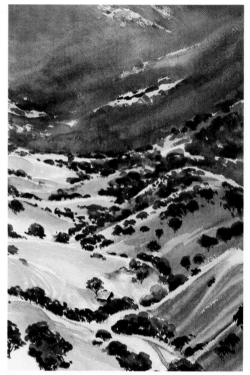

Figure 208

Down into a California Valley
Watercolor, 15⅝ x 11½ inches

The challenge here was to get the gradual cooling of color from foreground up into the distant hills. A thin wash of cadmium orange created the tawny grass.

Figure 207

Winter Limestone Quarry
Watercolor, 14 x 21½ inches

I started out in sunshine to paint this location, but clouds moved in, to my disappointment. However, the soft light brought out the warm grays of limestone, the background of woods, and the soft blue-gray snow shadows. The evergreens blended into the surrounding trees. The sky wash required a bit of cadmium yellow pale for the haze. A few days later I went over again to paint in sunshine. The shadows were deep and harsh. The mystery of the place had vanished.

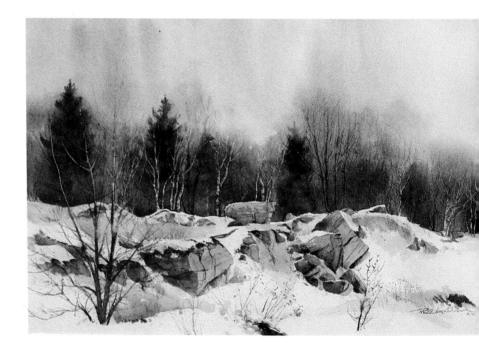

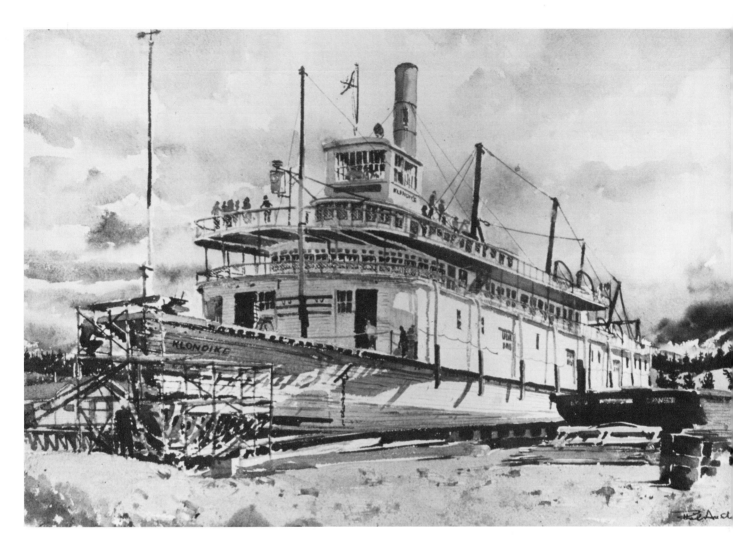

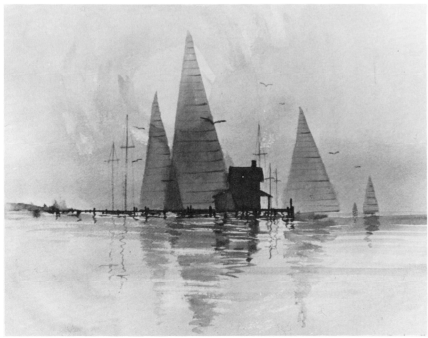

Figure 209

Restoring a Yukon River Boat

Watercolor, 14½ x 21½ inches
Collection of Canadian Department of Northern
and Indian Affairs

*This juggernaut of the Yukon Gold
Rush days is being restored and is one
of the last of the old river boats. A
fascinating subject.*

Figure 210

Sail House, a Fantasy
Watercolor, 11½ x 15⅝ inches

*This painting has no explanation for
its existence. It just drifted into mind.
The entire background of water and
sky was painted in warm tones of cad-
mium yellow and a little cadmium
orange. Varying tones of orange and
brown completed the sail boats, reflec-
tions, and the old pier and house.*

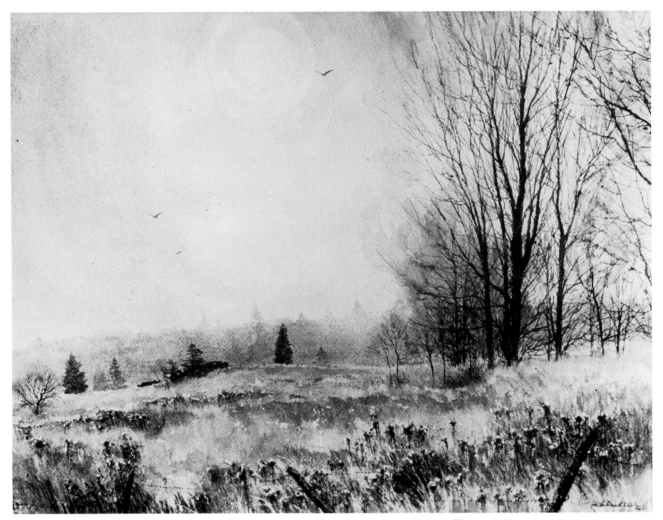

Figure 211
Indian Summer
Watercolor, 21x29 inches

Painted wet-on-wet on 300-pound D'Arches paper. After all soft areas were completed some dry-brush and brush-handle work was used in the foreground. Masking was used to hold light areas for weed heads. Trees, final details on weeds, fence, and hawks were added to dry surface.

Figure 212
Pattern of March Fields
Watercolor, 14 x 21½ inches

There is a stark beauty about the countryside before it awakens to spring. Snow lingers, making patterns of the fields. Woods carry a delicate pattern of limb filigree against the sky. Such times often supply the bases for interesting pictures.

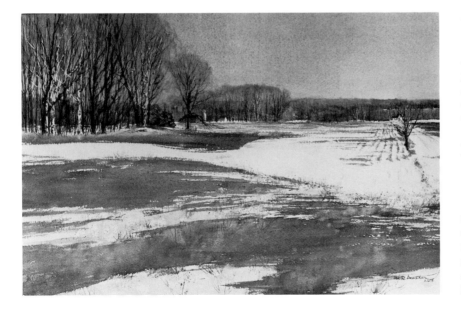

Figure 213

Loft with Skylight
Watercolor, 15⅝ x 11½ inches

This old loft was bathed with light because of a lot of missing shingles in the roof. A gray-green wash for the lighter areas gave an eerie look. The geometric patterns were beautiful.

Figure 214

Cherry Orchards
Watercolor, 14 x 21½ inches

The orchard was in stark contrast to the weathered gray shed. The tractor was a beautiful little silhouette. Vertical brush strokes in the building area were arbitrarily put in to darken the sky against nearby trees and to break up the large, simple foreground. I felt it made an interesting division between growing trees and man-made forms.

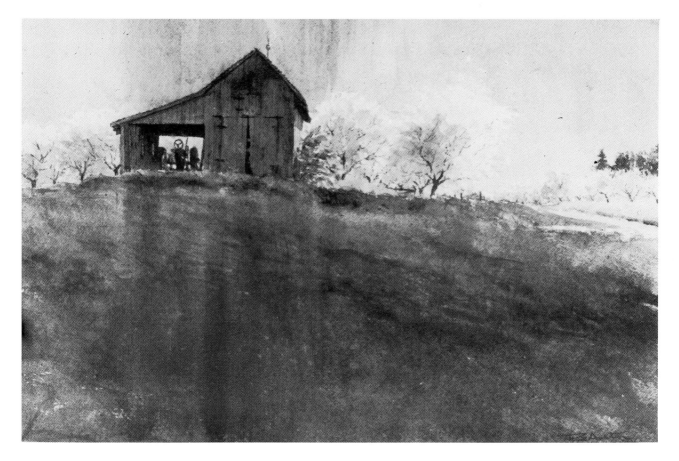

Figure 215

Mending Nets
Watercolor, 21½ x 29 inches

This endless job for our fishermen never ceases to fascinate me. The rocks and nets make a beautiful pattern. Dry brush grass contrasts with the large, simple net areas.

Figure 216

On the Beach, Mont St. Pierre
Watercolor, 21x28½ inches

This strong pattern of a community along the St. Lawrence has a lot to say about living and working in the same neighborhood. The heavy boats suggest rugged work. Overlap is very evident and very useful in this painting. Detail is pretty well confined to the boats and beach.

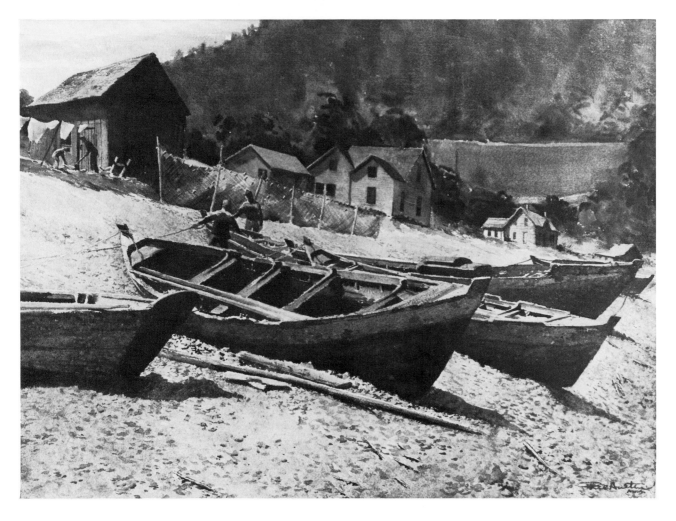

Figure 217

High Tide at Sandy Cove
Watercolor, 21½ x 29 inches

This was an exciting area along the Bay of Fundy. The color was good, but somehow I never did develop a good value pattern. Note the much better values and stronger compositions in the other paintings in this spread. This painting needs considerable study with sketches and readjusting of values. Perhaps it should even become two separate paintings.

Figure 218

Evening at Indian Harbour
Watercolor, 11½ x 15⅝ inches

Simple lights and darks can pull a lot of small objects into a very effective composition as has been done in this painting of Nova Scotia.

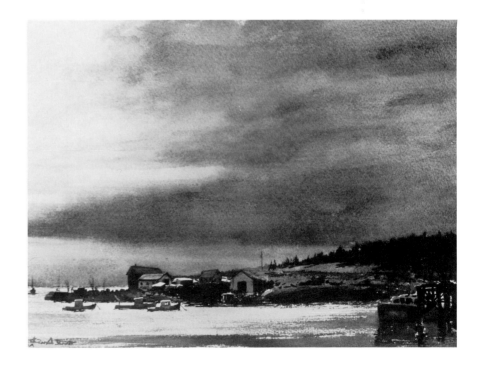

Figure 219

Dark Morning, Percé
Watercolor, 11¹/₂ x 15⁵/₈ inches

The sky was painted first with a light wash of cadmium yellow. Then into this was flooded a mixture of cerulean and some vermilion, producing a cool gray. Percé Rock and the adjacent shore were put in very dark to create the greatest contrast. A simple indication of reflections, shore, and nets was all that was needed to complete the story.

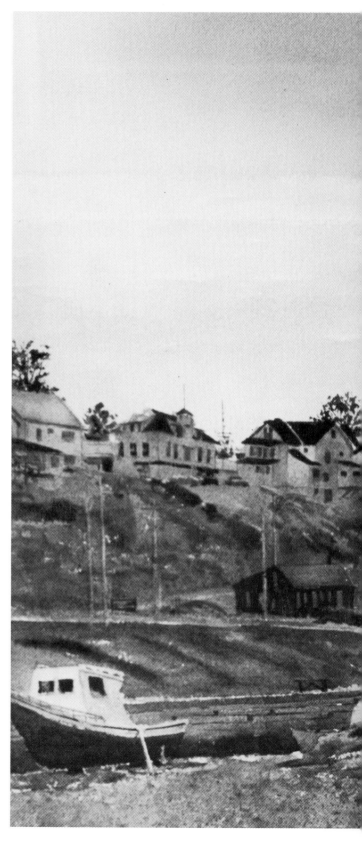

Figure 220

Cap au Renard Gaspé
Watercolor, 21¹/₂ x 29 inches
Collection of Mr. and Mrs. Gordon Bent

I began with the sky, a changing mass of curdled clouds with long horizontals below, a perfect backdrop for the village on the bluff. The afternoon light silhouetting the slender steeple and the foregound in reduced light, contained a story as well: tides, fishing boats—some floating, some pulled up, some awaiting repair—the story of Gaspé.

182

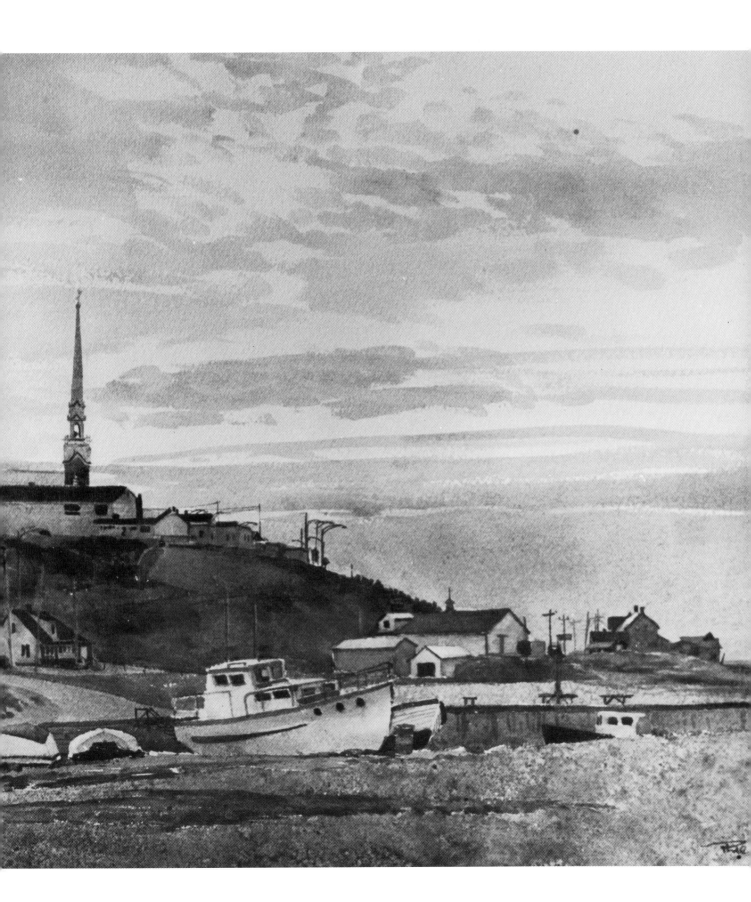

Figure 221

The location in this picture—Shrimp Olson's farm, "Kari's Ridge"—has been the subject of many of my watercolors.

Figure 222

Fog on Kari's Ridge
Watercolor, 21x29 inches

I did a fall plowed field with new snow drifted in the furrows. I concluded it would work well with this old farm up on the ridge. The fog was introduced to push the farm back. The deeper snow made excellent negative space in the front left. Snow on the house roof was a small repeat.

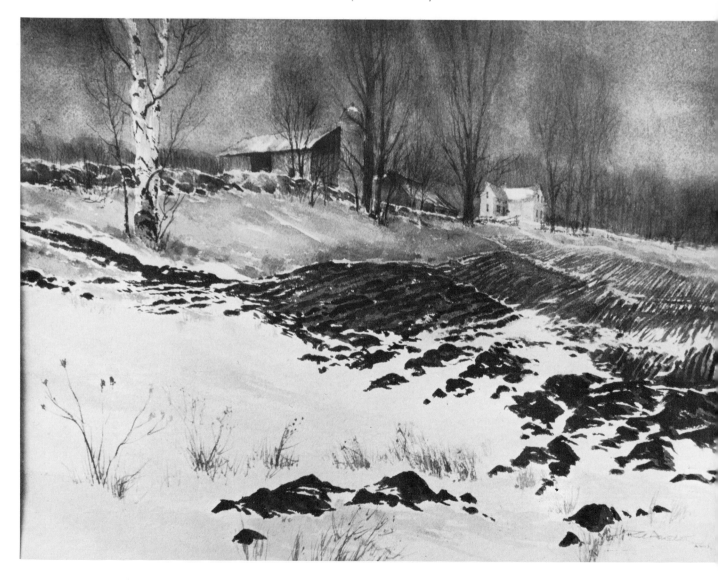

Figure 223

Florida Potpourri
Watercolor, 21¹/₂ x 29 inches

This old river tug towering over the
surrounding boats created a striking
contrast. I made some changes, some
simplification, moved the palm trees a
bit in the interest of a better composi-
tion, and hastened to capture it on a
sheet of D'Arches rough.

Figure 224

Afternoon in Sitka
Watercolor, 14 x 21¹/₂ inches

The afternoon sun etched the main
street of this old Russian capital of
Alaska in light against the deep
greens of the mountain behind it. Val-
ue and color joined to play an impor-
tant part in this painting.

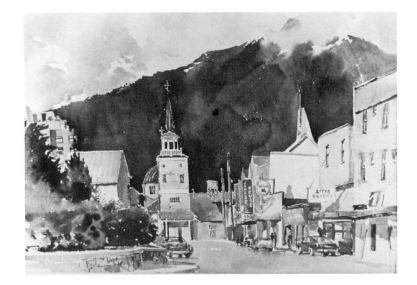

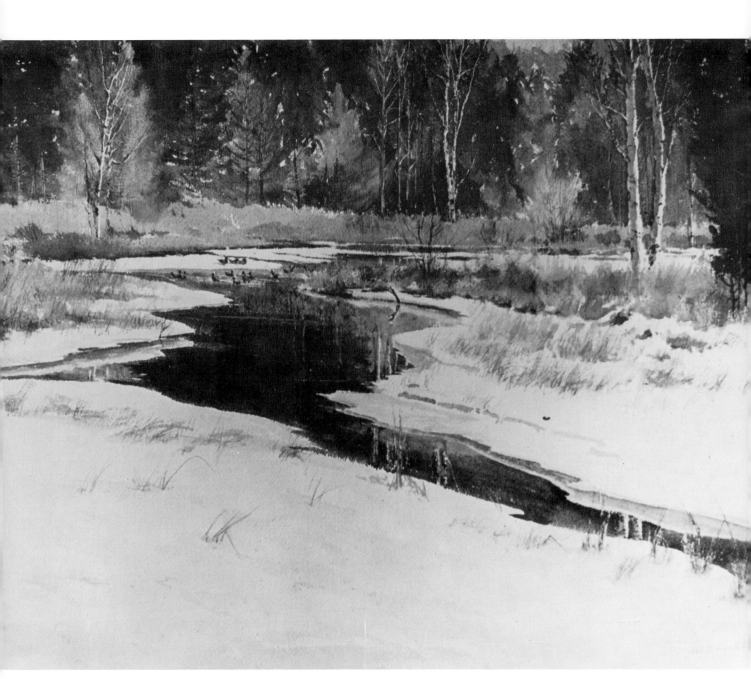

Figure 225

Early Arrivals
Watercolor, 21x29 inches
Collection of Kierney and Trecker

This creek in Peninsula State Park is a winter treat. It is always different. The ice never opens up with the same pattern. The woods catch the light differently. The depth of the snow creates a different pattern of weed stalks and dry grass, and in this case, the ducks had moved in, adding activity. The white snow creates excellent negative space against the dark water.

Figure 227 ▶

Sun After Shower, Mendocino
Watercolor, 21½ x 29½ inches

The sun, burning through the rising fog, picked up the fronts of the buildings and the picket fences, contrasting with the shadow sides of each object. The darker sky tone gave a feeling of the glare of light. The puddles picked up bits of the same contrast.

Figure 226

The Last of Fall
Watercolor, 13¾ x 21 inches

Varying verticals, dark and light, horizontals of sky, clouds, and grass make a grid of the emptiness of fall, the very bones of the landscape.

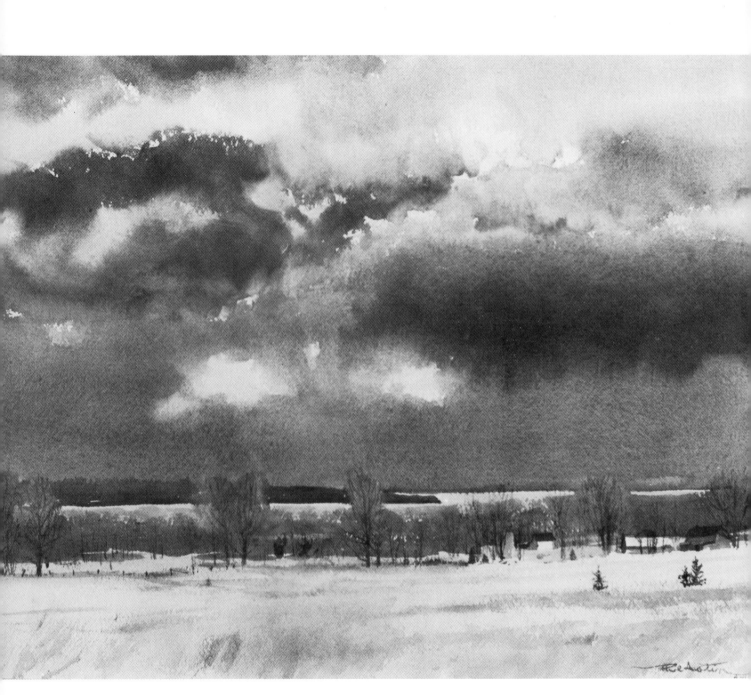

Figure 228

Storm Clouds Over Rowley Bay
Watercolor, 11¹/₂ x 15⁵/₈ inches

These dramatic snow clouds were tumbling out over the bay. I dashed in the sky first, lest I lose it, then composed the scene below it, regrouping trees and farm buildings. Exciting skies like this are either won or lost in five minutes. The distant woods and nearby trees were painted together, using frequent brush-handle strokes in the damp wash. The foreground was done with a very light, dry-brush stroke, using a one-inch flat wash brush.

Figure 229

Fall Escarpment
Watercolor, 21x29 inches

This painting, in contrast to Figure 222, is a very deliberate one with much attention given to comparative masses of rock, texture, and value. This tells the story of the geology of the area and the persistence of tree growth as well. Large washes were applied for value, then additional values added, finishing with detail.

Figure 230

Fishermen, Mazatlan
Watercolor, 21x29 inches
Collection of Mrs. Phil Austin

This painting, done from some lucky slides taken from the deck of the ferry in Mexico, took considerable planning, but very rapid painting of the water to give it movement. Lost and found edges on the boat and figures tie it all together.

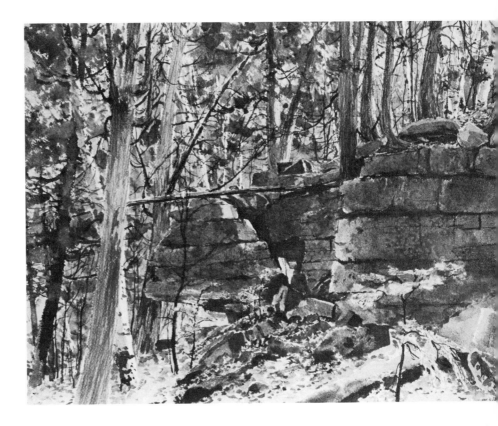

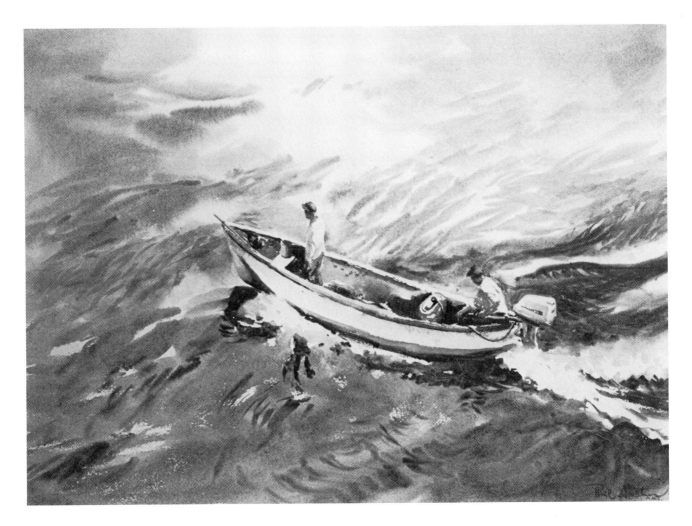

Index